MASTERPIECES OF PAINTING
IN THE J. PAUL GETTY MUSEUM

MASTERPIECES OF PAINTING
IN THE J. PAUL GETTY MUSEUM

Burton B. Fredericksen

THE J. PAUL GETTY MUSEUM
MALIBU · CALIFORNIA
1988

Library of Congress Cataloging-in-Publication Data

J. Paul Getty Museum.
 Masterpieces of painting.

 Includes index.
 1. J. Paul Getty Museum—Catalogs. 2. Painting—
California—Malibu—Catalogs. 1. Fredericksen, Burton B.
11. Title.
N582.M25A63 1988 750'.74'019493 88-2924
ISBN 0-89236-137-9 (pbk.)
ISBN 0-89236-141-7 (hbk.)

Cover: HENDRICK TER BRUGGHEN (Dutch, 1588–1629).
Woman with an Ape: Allegory of Taste (?), 1627. Oil on
canvas. 102.9 x 90.1 cm (40½ x 35½ in.). 85.PA.5.

Back cover: AMBROSIUS BOSSCHAERT THE ELDER
(Dutch, 1573–1621). *Basket of Flowers*, 1614. Oil on
copper. 28.6 x 38.1 cm (11¼ x 15 in.). 83.PC.386.

Printed in Japan

CONTENTS

FOREWORD

Turning the pages of this book gives all of us who work at the Getty Museum a particular feeling of exhilaration. This is a young institution with a daunting job, to build important collections in a time of dwindling supply. Burton Fredericksen's survey of our finest paintings gives a measure of our progress in the last decade, for the reader who cracks the code of accession numbers will discover how many of the works have been acquired recently.

J. Paul Getty had a puzzling attitude toward European paintings from the late Middle Ages until around 1900, buying them with only fitful enthusiasm. Not until after his death, when the Museum received the benefit of his generous legacy, could the paintings collection be greatly strengthened. As the Museum's curator of paintings between 1965 and 1984, Burton Fredericksen brought a new level of professionalism to collecting, exhibiting, and publishing. His work has spanned several eras, beginning at Mr. Getty's modest house-museum in the 1960s, continuing through the construction in 1968–1974 of the present Museum and into the present period of diversification by the Getty Trust and of growth for the Museum. Mr. Fredericksen's contribution to the development of the Museum's collections and to the seriousness of its purpose has been fundamental. It is celebrated with the publication of this book.

John Walsh
Director

INTRODUCTION

This is the second book to concentrate on the most prized paintings in the J. Paul Getty Museum. An earlier selection of fifty-one paintings was published in 1980, just as the influence of Mr. Getty's magnificent endowment was beginning to be felt; all but a few of the pictures included at that time had been purchased within the preceding decade. The present volume contains only thirteen of the paintings previously illustrated, however, indicating the number of significant acquisitions that have been made by the Museum's Department of Paintings since 1981. New works continue to be added, and even since the completion of this manuscript, major paintings by David and Cézanne have entered the collection.

In light of the considerable refinement and expansion that the paintings collection has undergone within a relatively short span of time, it is worth recalling its history. Mr. Getty did not actively begin to collect until the 1930s, and from the start he gave most of his attention to the French decorative arts. Paintings he acquired almost casually with the intention of displaying them in his home. He disliked competing with museums for pictures, and he reasoned that a major item of French decorative art could be purchased for a fraction of the cost of a comparable painting. He did not, in fact, consider himself to be a collector of paintings. Despite this, he came to purchase two major works, as well as a number of lesser paintings, early in his collecting career. The first picture of importance to enter his collection was Gainsborough's *Portrait of James Christie* (no. 48), purchased in London in 1938. Shortly after, he bought Rembrandt's *Portrait of Marten Looten* (later donated to the Los Angeles County Museum of Art), perhaps the most important painting he was ever to acquire.

With the outbreak of World War II, Mr. Getty was temporarily forced to curtail his collecting, and he did not begin again until the 1950s. In 1953 he first opened his collections to the public in four galleries located in a ranch house behind the present Museum building. Although the strengths of the Museum remained in the decorative arts and, later, in Greek and Roman antiquities, he nevertheless acquired more paintings during the 1950s and 1960s. Among them were two very important works, Rembrandt's *Saint Bartholomew* (no. 25) and Veronese's stunning *Portrait of a Man* (no. 10).

In the late 1960s Mr. Getty made the decision to construct a new Museum building in Malibu, modeled after the Villa dei Papiri in Herculaneum, which had been buried by the eruption of Mount Vesuvius in A.D. 79. Many paintings were added to the collection at this time, and its scope was broadened considerably to include areas not previously represented, such as works from the French, early Flemish, and fourteenth-century Italian schools.

Despite the growth of the Museum and the addition of a small professional staff, the collection retained the stamp of its founder, who personally approved each purchase; he demonstrated a marked preference for large paintings with secular and mythological themes. Among the most significant of the pictures acquired between 1969 and 1972 was Georges de La Tour's powerful *Beggars' Brawl* (no. 31).

By the time the new building was opened to the public in 1974, all three of the Museum's collections—decorative arts, antiquities, and paintings—had been considerably expanded. The paintings collection, however, remained the least developed. During the next two years, acquisitions continued at a slower rate, and the Museum's focus became research and catalogue preparation.

After Mr. Getty's death in 1976, it was learned that the bulk of his estate had been left to the Museum and that an expansion of the collections far surpassing anything yet witnessed would be possible. From 1977 to 1979, when funds began to become available, some of the Museum's most significant works by early Italian Renaissance artists were obtained, including paintings by Gentile da Fabriano (no. 2), Masaccio (no. 3), and Carpaccio (no. 6).

With the settling of the estate in 1981 and the institution of a carefully considered acquisitions policy, a new phase of collecting began, and emphasis was given to improving the paintings collection. A series of outstanding pictures was acquired, beginning with *The Holy Family* by Poussin (no. 33). Also included in this group were the first major works by Impressionist artists—Pissarro (no. 41), Monet (no. 40), Degas (no. 44), and Lautrec (no. 46). The first important Dutch landscapes (no. 24), still lifes (nos. 18, 29), and genre pieces (nos. 26, 27) were also acquired.

During the last three years such masterpieces as *The Annunciation* by Bouts (no. 16), the *Adoration of the Magi* by Mantegna (no. 5), and the *Portrait of a Bearded Man* by Salviati (no. 9) have been purchased. Many superlative works from the nineteenth century—a period that previously was scarcely represented in the collection—by artists such as Gericault (no. 36), Millet (no. 39), Courbet (no. 38), Cézanne (nos. 42, 43), and Munch (no. 51) have also been added.

To form a comprehensive collection of great paintings is no longer possible today because of the diminishing numbers available and the escalation of prices. The cost of a single major work now may sometimes exceed that of an entire collection only a decade ago. Nonetheless, through carefully considered additions, the Museum's collection continues to take on more depth, variety, and quality. We trust that visitors to the Museum will find the paintings galleries rewarding and worthy of repeated visits and that the present selection of masterpieces will prove to be just one of a series documenting the growth and improvement of the collection.

Burton B. Fredericksen
Senior Curator for Research

SIMONE MARTINI
Italian, circa 1284–1344
Saint Luke, 1330s
Tempera on panel
67.5 x 48.3 cm (26⁹⁄₁₆ x 19 in.)
82.PB.72

A bastion of conservatism, fourteenth-century Siena was not immediately affected by the progressive currents that the Renaissance brought to Florence and parts of northern Italy. The adherence to a more orthodox, and therefore less experimental, tradition allowed local artists to maintain and perfect particularly high standards of craftsmanship. During the first half of the fourteenth century, however, a number of Sienese artists did begin to soften the rigidity of the local Byzantine-influenced style. Simone Martini was perhaps the most accomplished of this group. In his hands the figure became more elegant and graceful, and the long-established stylizations of his predecessors began to give way to a greater awareness of the human form and its potential for beauty. Simone often worked for patrons in cities such as Avignon in France that were considerably removed from his birthplace. The poems that Petrarch wrote in his praise spread his reputation and that of the Sienese school beyond the borders of Italy.

The Museum's panel depicts Saint Luke, who is identified by the inscription *S. LVC[A]S EVLˢTA* (Saint Luke the Evangelist). A winged ox, the saint's symbol, holds his inkpot as he writes his Gospel. This painting is in nearly perfect condition and retains its original frame. It was probably the right-hand panel of a five-part portable polyptych, or multi-part altarpiece. The remaining four sections (three of which are in the Metropolitan Museum of Art, New York, and the fourth of which is in a private collection in New York) depict the Madonna (the central panel) and three other saints. The panels were probably hinged together with leather straps so that the altarpiece could be folded and carried. Holes in the top of the frame indicate that there may have been attachable pinnacles, perhaps with angels. The fully expanded altar would have been almost seven feet in width.

Portions of some of the panels were painted by the artist's assistants, but the Getty Museum's panel was executed entirely by Simone. The refinement of design, extreme elegance of the hands, slightly elongated figure, and intensity of the expression are all hallmarks of his work.

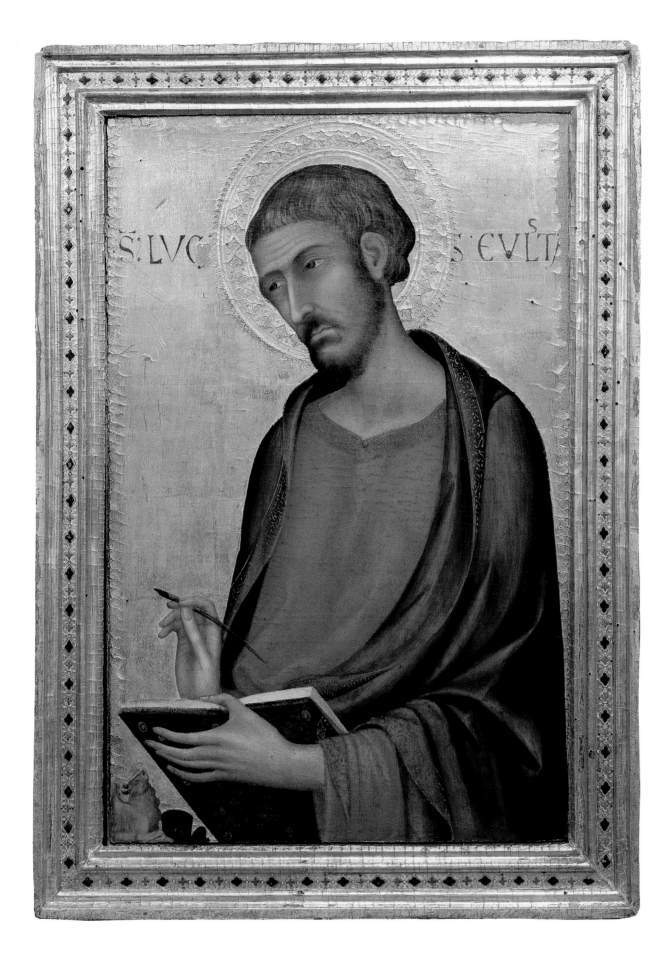

GENTILE DA FABRIANO
Italian, circa 1370–1427
Coronation of the Virgin, circa 1420
Tempera on panel
87.5 x 64 cm (34½ x 25¼ in.)
77.PB.92

A rare surviving example of a processional standard, the *Coronation of the Virgin* was meant to be carried on a pole in religious parades. It is painted in brilliant colors over a layer of gold leaf and must have once had an image of God the Father in a tympanum, a separate section that was attached above; this has since been lost. The standard was also originally double sided and was sawn into two sections sometime prior to 1827. The reverse, the *Stigmatization of Saint Francis,* is now in the Magnani-Rocca collection in Reggio Emilia in northern Italy.

The choice of subjects and the evidence of existing documents indicate that the standard was painted for the Franciscan monks in Fabriano and kept at the church of San Francesco. The painting was moved about to different locations over the course of the next four centuries, as churches were torn down and replaced, but because of its connection with Gentile, the town's most famous son, it was revered in Fabriano long after such paintings ceased to be made. By the 1830s, however, such relics of the late Middle Ages and Renaissance had become highly coveted, and an English collector was able to purchase the *Coronation.*

Gentile is thought to have painted the standard on a visit to his hometown in the spring of 1420, rather late in his illustrious career. By this time he had acquired fame and prestige throughout Italy as the greatest artist of his generation. Although relatively few of his paintings survive, his works had an enormous influence (in part because of their strong sense of space and form) on his contemporaries.

In the Museum's panel, the artist has composed his scene using a number of rich fabrics with large and colorful patterns, a device that did not permit him to develop the spatial aspects of the painting to his usual degree. Christ both blesses and crowns the Virgin, an unusual detail for this time, while to each side the angels sing songs inscribed on scrolls. The total effect is one of luxuriousness and opulence befitting a panel that was once one of the town of Fabriano's most venerated religious treasures.

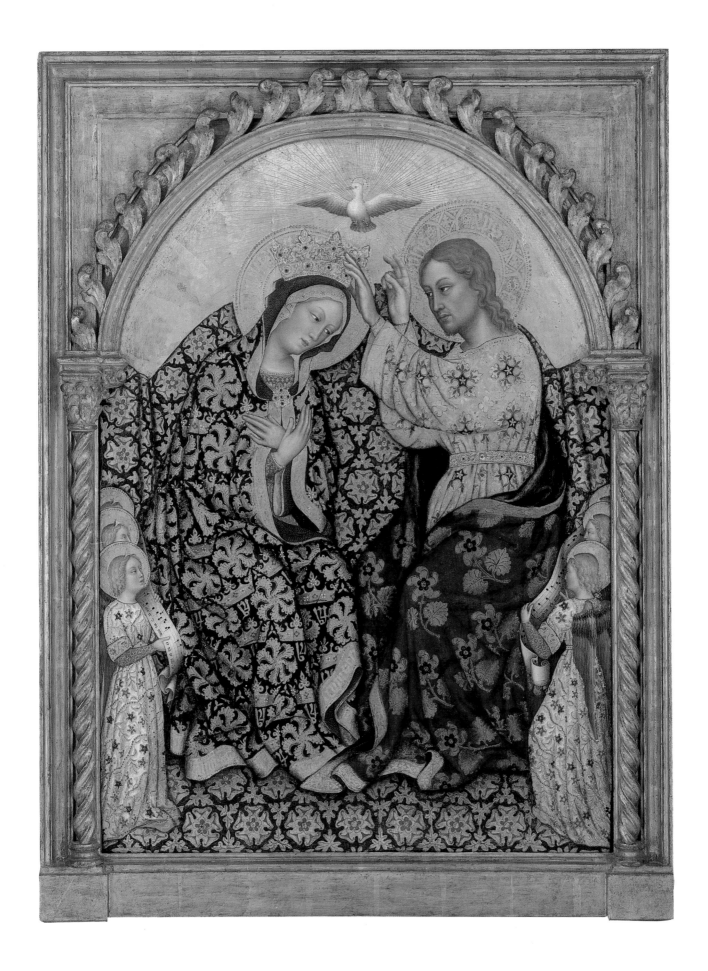

MASACCIO (TOMMASO DI GIOVANNI GUIDI)
Italian, 1401–1428(?)
Saint Andrew, 1426
Tempera on panel
52.4 x 32.7 cm (20⅝ x 12⅝ in.)
79.PB.61

Masaccio's brief but unparalleled career was marked by a few major works, including an altarpiece painted for the church of the Carmine in Pisa; a cycle of frescoes for the Brancacci chapel in the church of the Carmine in Florence; and a fresco depicting the Trinity in the church of Santa Maria Novella in Florence. All were painted within a span of about four years, but the only one of these that is clearly documented from the time is the altarpiece for Pisa, an epochal work that became famous immediately. It is to this altarpiece that the Museum's panel once belonged.

Masaccio, a citizen of Florence, began work on the Pisa altarpiece in February 1426, and he must have spent much of his time in Pisa until its completion the day after Christmas. The chapel in which it was to be placed had been constructed the year before at the request of Ser Giuliano di Colino degli Scarsi, a well-to-do notary in Pisa. The notary's records of payment show that Masaccio used two assistants, his younger brother Giovanni and Andrea di Giusto, both of whom later became respected artists in their own right.

The central part of the altarpiece, now in the National Gallery, London, depicts the Madonna and Child with angels singing and playing instruments. At the sides were panels of saints Peter, John the Baptist, Julian, and Nicholas (now presumed lost). In the predella, the platform or base under the altarpiece, were stories from the lives of these saints and the *Adoration of the Magi* (all of which are now in the Staatliche Museen Preussischer Kulturbesitz, Berlin). Above the Madonna was the *Crucifixion* (most probably the painting now in the Museo e Gallerie Nazionali di Capodimonte, Naples), and on either side in the upper register were many other saints. The Getty panel of Saint Andrew is presumed to have been one of these. The entire altarpiece was about fifteen feet tall, a large and imposing construction.

The value of Masaccio's work lies in its innovative rendering of the figure and its very original understanding of form and volume, both of which are seen in the monumentality and solidity of the figure of Saint Andrew. The artist is given credit for having begun an entirely new phase in the history of painting and for being the first since classical times to project a rationally ordered illusion of space onto a two-dimensional surface. As much as any other painting, this altarpiece marks the beginning of the period known as the Renaissance in fifteenth-century Tuscany.

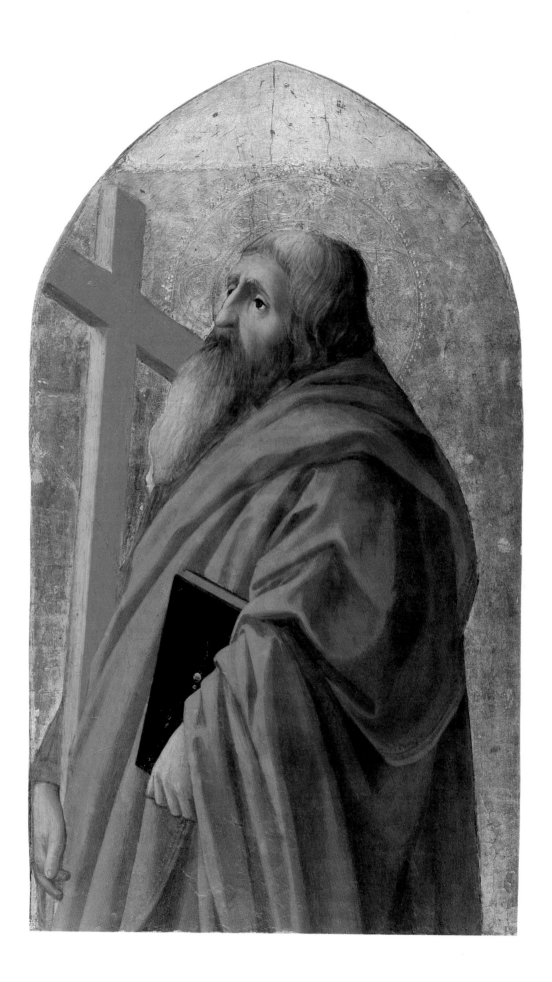

BARTOLOMEO VIVARINI
Italian, active 1450–1491
Polyptych with Saint James Major, Madonna and Child, and Various Saints, 1490
Tempera on panel
215 x 280 cm (84⅝ x 110¼ in.)
On central panel, inscribed *OPVS FACTVM. VENETIIS PER BARTHOLOMEVM VIVA / RINVM DE MVRIANO 1490* by the artist
71.PB.30

Bartolomeo Vivarini was a member of a family of artists who lived on the island of Murano in the Venetian lagoon. They created paintings for churches and religious institutions over a wide area of northern Italy, Dalmatia, and even Apulia in southern Italy—lands that came under Venetian influence during the second half of the fifteenth century.

Although the frame is not original, the construction of the Museum's polyptych is otherwise typical of those produced in the Venetian area during the early Renaissance. The central figure is either Saint James Major or Christ dressed as a pilgrim; this attire would suggest that the church from which the altarpiece may have come, San Agostino in Bergamo, was frequented by pilgrims. On either side of the central panel are full-length figures of saints John the Baptist, Bartholomew, John the Evangelist, and Peter. In the upper tier are saints Lucy, Ursula, Apollonia, and Catherine, seen in half-length with the Madonna and Child in the center. The setting for Saint John the Baptist (lower left) is a landscape with a small ledge of dirt apparently worn away by water, perhaps suggesting the river Jordan. This natural background contrasts with the marble floors on which the neighboring saints stand. Such a break in symmetry is unusual.

Bartolomeo was one of the most prominent practitioners of a tradition that was particularly "sculptural" in character. It reflected a desire to precisely delineate every inch of the surface of a painted figure, thereby giving it the appearance of a wood carving. This "sculptural" style derived from Paduan artists, particularly Mantegna (see no. 5). Unlike most of the artists of Padua, however, Venetian painters were initially less interested in emulating classical art and preferred to concentrate on traditional sacred themes. This changed at the end of the fifteenth century, shortly after this altarpiece, one of Vivarini's last works, was executed.

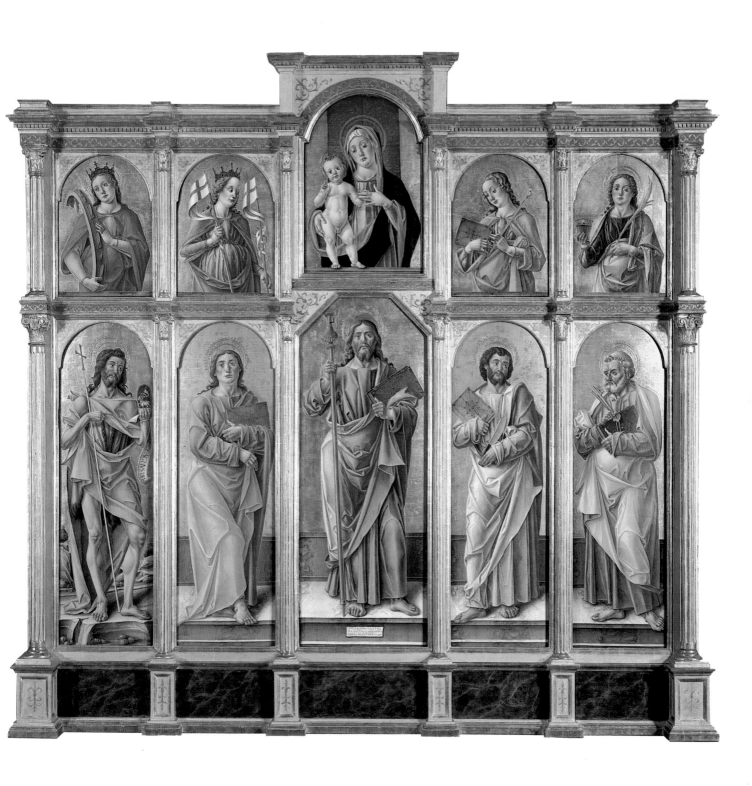

ANDREA MANTEGNA
Italian, circa 1431–1506
Adoration of the Magi, circa 1495–1505
Tempera on canvas
54.6 x 70.7 cm (21½ x 27⅞ in.)
85.PA.417

The Renaissance was characterized by an intense reawakening of interest in classical art and civilization. During the fifteenth century, some of the most overt emulation of "classical" style occurred in northern Italy, especially Padua and Mantua. This was primarily due to the influence of Andrea Mantegna, who worked in both cities and spent much of his career in the court of Lodovico Gonzaga, Marquis of Mantua.

Although Mantegna probably had no examples of classical painting for study, he did have access to some sculpture and to recently excavated fragments of Roman figures and reliefs. In his religious pictures, as well as his works with classical or mythological themes, the emphasis on sculptural models is apparent. His style is characterized by sharp definition of figures and objects, combined with a clear articulation of space. Some of his pictures are executed in grisaille, or tones of gray, as if he were imitating reliefs, and they give the impression of having been carefully carved in great detail.

The Museum's canvas was most probably painted in Mantua, very possibly for Lodovico Gonzaga. It has a completely neutral background with no attempt to indicate a setting. Kneeling before the Holy Family are the three kings: the bald Caspar, Melchior, and Balthasar the Moor. The hats worn by Melchior and Balthasar are reasonably accurate representations of oriental or Levantine headgear. Caspar presents a blue-and-white bowl of very fine quality Chinese porcelain (one of the earliest depictions of oriental porcelain in Western art). Melchior holds a censer, which has been identified as Turkish tombac ware, and Balthasar offers a beautiful agate vase. Objects of this sort were not commonly found in Italy, although some of the costume accessories might have been seen in Venice, which maintained an active trade with the East. They may have been gifts from foreign heads of state that formed part of the Gonzaga collections.

The Museum's *Adoration* is one of the few fifteenth-century Italian paintings executed on linen instead of wood. Such pictures were not originally varnished because they were painted in tempera rather than oil. Varnish applied at a later time has darkened the canvas, but the beauty of the figures and the richness of the detail have hardly been affected.

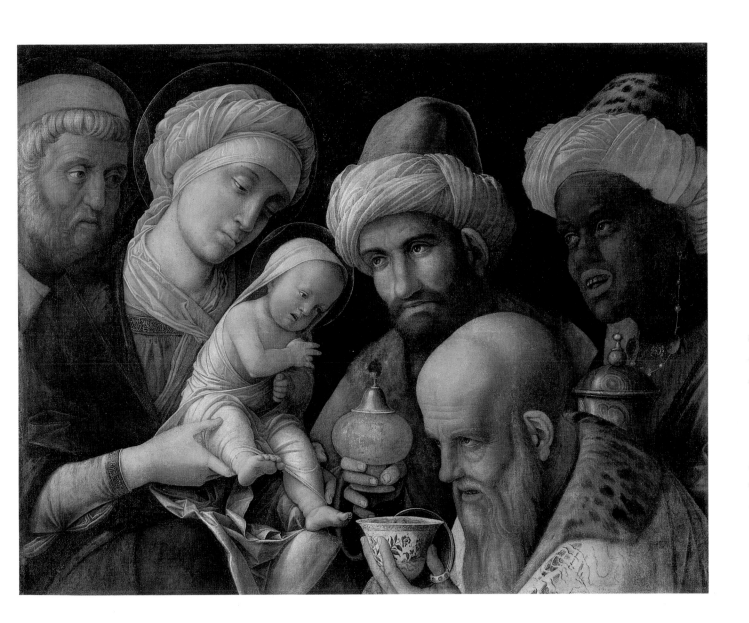

VITTORE CARPACCIO
Italian, 1455/56–1525/26
Hunting on the Lagoon, circa 1490–1496
Oil on panel
75.4 x 63.8 cm (30 x 25 in.)
79.PB.72

Carpaccio is frequently credited with having been the first great Renaissance painter of genre subjects, often including details of Venetian life in paintings whose primary themes are religious. The Museum's painting appears to be one of the few whose theme was entirely secular, perhaps because it was utilized as a shutter, most likely for a window. The members of a hunting party are shown in six boats chasing what appear to be grebes, birds desired for their feathers. Shooting terracotta pellets from small pouches on their bowstrings, the men seek to stun the birds rather than kill them or damage their valuable plumage.

The panel was certainly cut down at least on the bottom, and the truncated lily in the foreground may have originally been depicted in a vase sitting on a painted window ledge. Another even more unusual painting on the reverse, a trompe l'oeil (illusionistic) still life, appears to preserve its original dimensions, at least on the top and both sides. Grooves cut in the back indicate that at some time the panel had hinges and a latch. When closed over a window, it would have afforded its owners the illusion of looking out at the Venetian lagoon. From the outside a passerby saw the trompe l'oeil still life on the back of the panel, which depicted letters addressed to the occupants pinned up as if a messenger had just delivered them. There is virtually no other example of such illusionism prior to the time of the Museum's panel.

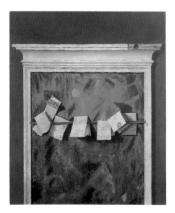

Vittore Carpaccio, *Letter Rack* (reverse of *Hunting on the Lagoon*).

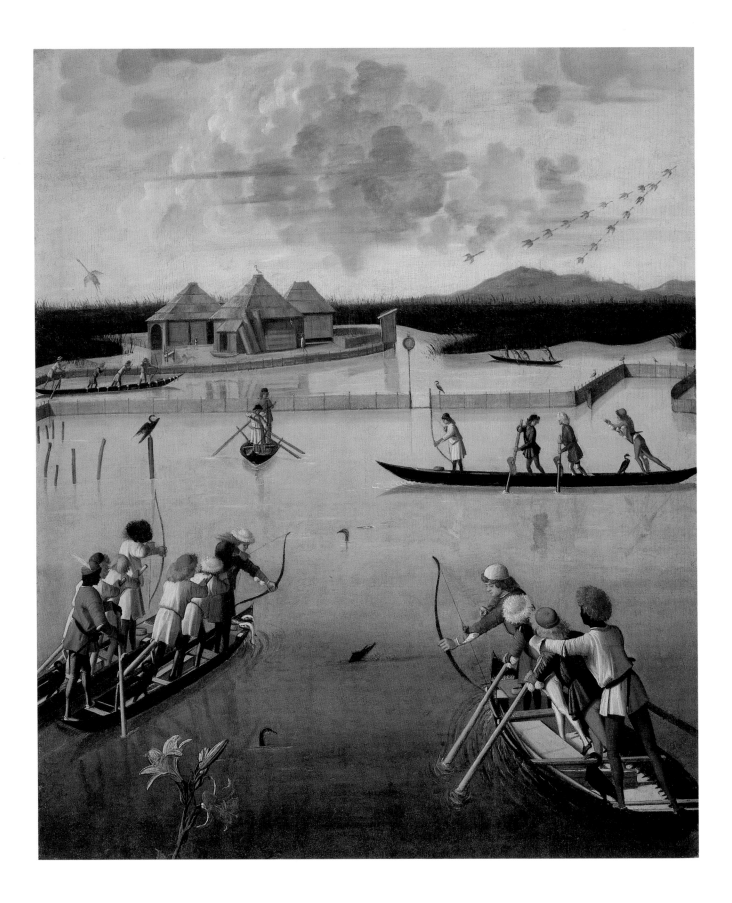

GIOVANNI GEROLAMO SAVOLDO
Italian, circa 1480–after 1548
Shepherd with a Flute, circa 1525
Oil on canvas
97 x 78 cm (38³⁄₁₆ x 30¹¹⁄₁₆ in.)
85.PA.162

Savoldo was born in Brescia, a city that alternately came under the political and artistic influences of Lombardy and Venice, and he seems to have spent most of his adult life in the latter city. Although his style is visibly the result of extensive contacts with other Brescian and Venetian artists, it also contains highly individual elements, the origins of which are difficult to trace. His figures show an unusually high degree of preliminary study, and their costumes appear to derive from work with actual fabrics and a close study of lighting effects. Savoldo seems also to have spent a great deal of time studying his models' features, and as a result their faces are usually portraitlike. Because he often depicted his subjects at dusk or even at night, there is a heightened sense of realism in much of his work, which seems to anticipate painters of the next century, especially Caravaggio and some of his followers (see no. 30).

The precise meaning of the Museum's painting is not yet understood. Shepherds appear in many Venetian paintings, often populating idyllic landscapes. Depictions of musical shepherds, however, are relatively rare, and the Museum's painting very probably has some connection to the revival of pastoral poetry that occurred in Italy at this time. The poetic tradition held that shepherds were free from the corruptions of urban life and that the rustic simplicity of their existence uniquely qualified them to speak on subjects such as love and death.

Although the features of Savoldo's shepherd are relatively individualized, it is not likely that this is a portrait. A sixteenth-century depiction of a shepherd with no allegorical or religious allusions whatsoever would be unprecedented, and by having the shepherd point to the farmhouse in the background with its flock of sheep, Savoldo may have intended to indicate the charms of pastoral life.

It has been suggested that this is a night scene, but Savoldo painted on darkened surfaces, which have become darker over time, and in this case it is more probable that daytime was meant. The shadow cast by the rim of the shepherd's hat on his face implies that the sun is overhead, and the amount of activity in the farmyard in the distance also suggests daytime.

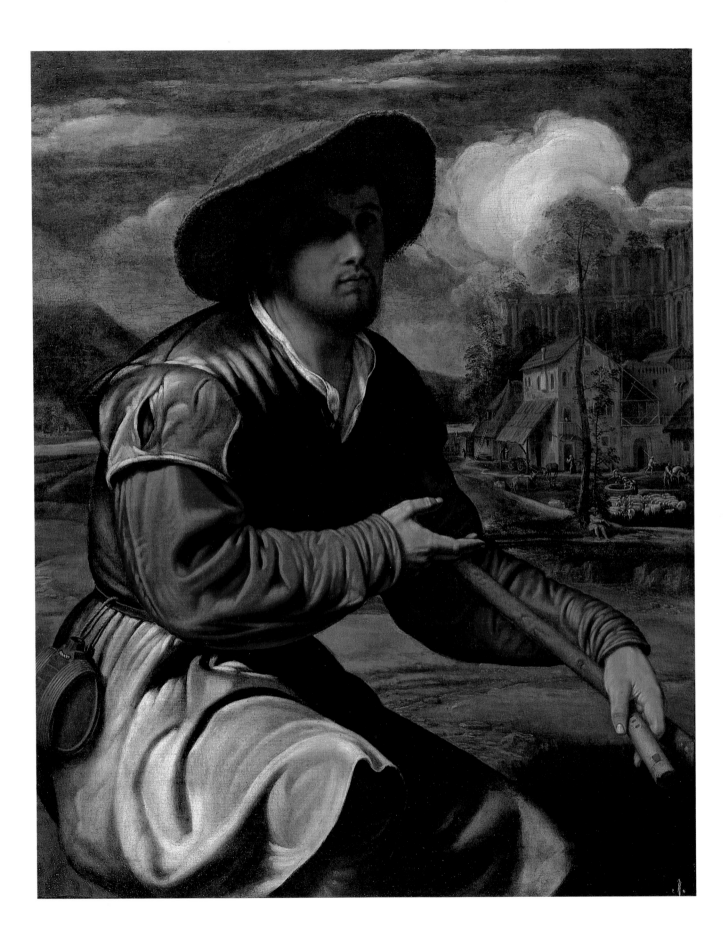

DOSSO DOSSI (GIOVANNI DE' LUTERI)
Italian, active 1512–died 1542
Mythological Scene, circa 1530s
Oil on canvas
160 x 132 cm (63 x 52 in.)
83.PA.15

During the early sixteenth century, the ducal court at Ferrara assembled and employed some of the most original and brilliant painters, writers, and musicians of the time. Most of this activity was initiated by Duke Alfonso I d'Este (1505–1534), who brought together painters such as Raphael from Rome and Giovanni Bellini and Titian from Venice. The collection of pictures that the duke assembled, however, focused primarily on the work of two local artists, the brothers Dosso and Battista Dossi.

The work of the Dossi combined elements of the Venetian style, as exemplified by Giorgione and Titian, with that of Tuscan or Roman artists such as Raphael. The brilliant color and poetic mystery of the Venetians pervade the brothers' works, but they also demonstrate a fascination with classical motifs and elaborate compositions and figural poses that seem to derive from Rome. The Museum's canvas, one of the largest surviving works by Dosso, exemplifies all of these influences.

Many of Dosso's best pictures still defy precise explanation because of their complex themes and eccentric or obscure allegorical programs. The Museum's painting is generally assumed to be mythological, because the Greek god Pan appears on the right. It has been suggested that the wonderful nude lying in the foreground could be the nymph Echo, whom Pan loved; the old woman may be Terra, Echo's protector. The music books on the ground would then refer to Echo's musical talents.

Dosso did not intend the woman in the flowing red cape on the left to be seen. After completing this figure, he painted over her with a landscape; this was scraped off at some more recent date. The artist's "final" composition contained only three principal figures, and without the red cape, it was more subdued in color. Sometime in the past, the painting was also cut down by about six inches on the left side, so that the figures originally dominated the composition to a lesser extent than they do now.

In spite of the changes that prevent us from seeing the painting exactly as the artist intended, it can be described as one of the most sensual and ambitious of Dosso's works. The beautifully detailed flower petals in the foreground, the almost flamboyant lemon tree, and the fantastic landscape on the left display an exuberance and individuality that are hardly matched by any of the artist's illustrious contemporaries.

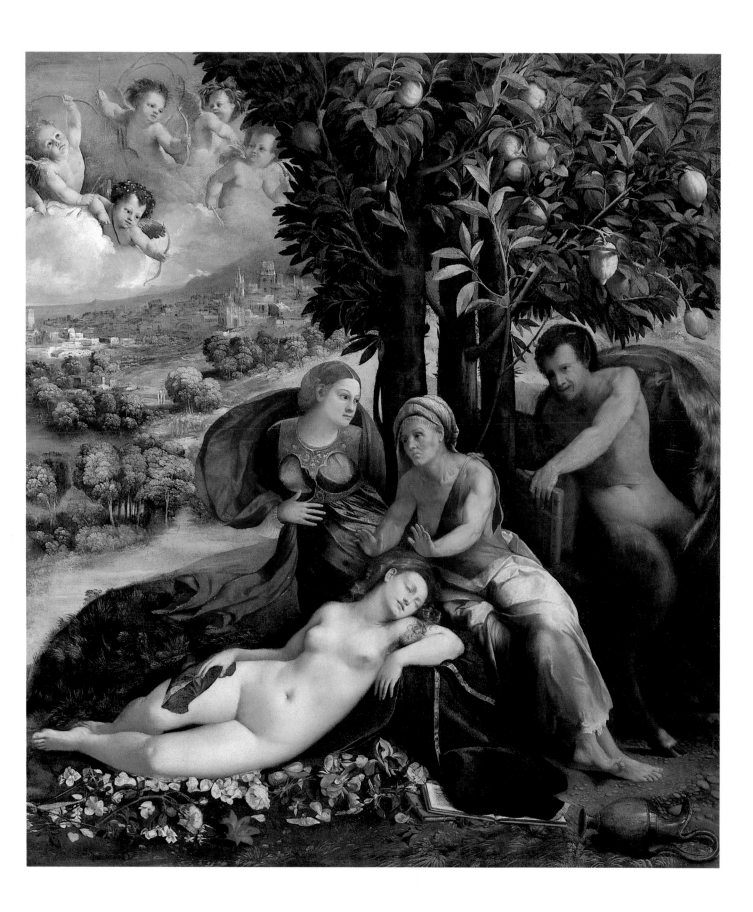

FRANCESCO SALVIATI (FRANCESCO DE' ROSSI)
Italian, 1510–1563
Portrait of a Bearded Man, circa 1550–1555
Oil on panel
108.9 x 86.3 cm (42⅞ x 34 in.)
86.PB.476

Portraiture has always been a part of the European painting tradition, but its potential for enhancing the political, social, and historical image of the subject was not fully realized or exploited in painting until the sixteenth century, during the High Renaissance. It was at this time that prospective sitters from a number of social levels fully came to understand how effectively portraiture could be used to control the way in which they were perceived by their peers or subjects.

Among those most successful at conveying the authority of their sitters were artists working in Florence and Rome, such as Bronzino and Francesco Salviati. Both men painted large numbers of portraits, and both excelled to the extent that they are best remembered today for these pictures rather than their figure compositions. Each artist succeeded in finding extensive patronage among the nobility, the wealthier merchant classes, and members of the court. Their depictions of stern, almost statuelike sitters are an important record of central Italian society of the time.

Bronzino was active most of his life in Florence, and his patrons, among them the powerful Medici family, were largely from that city. Salviati, who was greatly influenced by Bronzino and was in many ways his follower, was active in both Florence and Rome. His patronage was less consistent, however, and the names of his sitters are not always known. It is therefore particularly difficult to date Salviati's paintings accurately. This is true of the present painting, probably Salviati's portrait masterpiece. We know only that it comes from Florence and that the sitter was therefore probably a Florentine.

The artist has given his subject a very imposing air. Placed against a cascade of green drapery, his gaze is penetrating and his demeanor, severe. He holds a letter, something akin to a note of introduction, but his stance does not suggest any inclination to be introduced; instead it emphasizes his dignity and prestige.

Portraits of this sort, normally only half-length, are the painted counterparts of ancient Roman statues, and they have an almost marblelike quality. They are not painterly and lack a freedom of brushstroke and a love of spontaneity; instead, they are meant to suggest permanence and invulnerability.

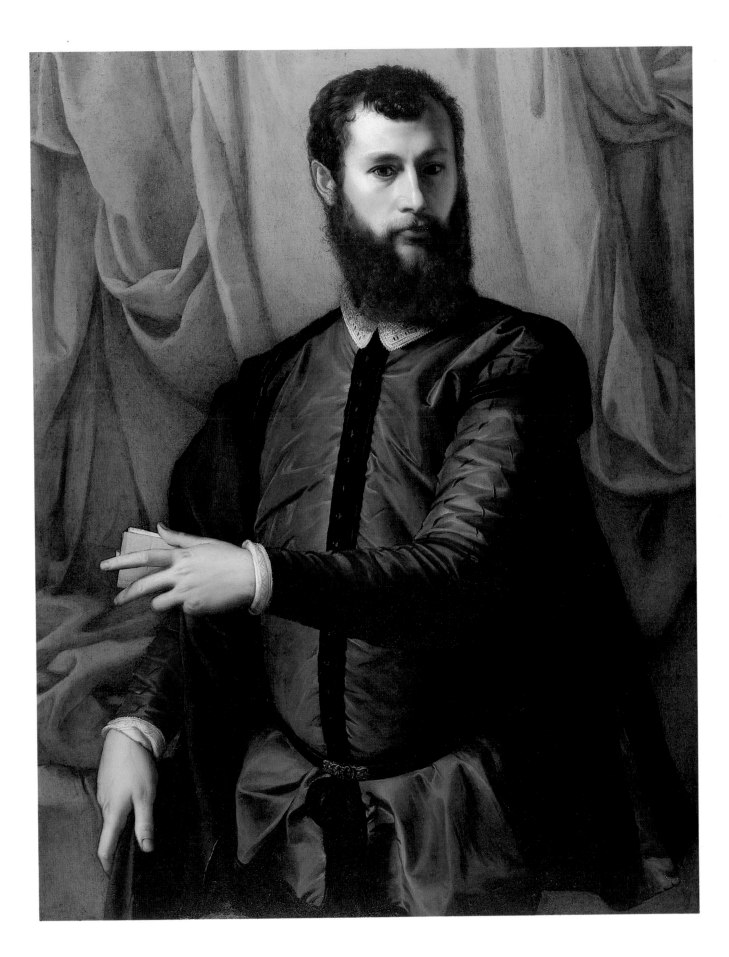

VERONESE (PAOLO CALIARI)
Italian, 1528–1588
Portrait of a Man, circa 1570
Oil on canvas
193 x 134.5 cm (76 x 53 in.)
71.PA.17

The subject of this imposing portrait leans on a large socle, or base, supporting fluted columns; between these columns is a niche containing a marble sculpture of a draped figure, only the lower portion of which can be seen. Carved reliefs adorn the sides of the socle, the exact subjects of which are not discernible. The man stands on a pavement of inlaid stone, and in the distance to the left, the distinctive features of the Venetian church of San Marco can be seen. The church is incongruously surrounded by trees as if it were in a forest instead of its actual urban setting. All of these details seem intended to provide clues to the subject's profession or identity. Perhaps he had some connection with San Marco, although this would not explain the church being represented in this unusual setting. He may have been an architect or even a sculptor, but nothing about his clothing or his appearance confirms this. The sword at his side, in fact, suggests that he may have been a nobleman.

Traditionally, the subject was described as the artist himself, but this cannot be confirmed. There are some indications that Veronese may have been bearded, and he seems to have had a high forehead, but his exact appearance is unknown. It seems unlikely, however, that he would have painted himself standing in formal clothing against some columns with a sword at his waist, and he had no special connection with the church of San Marco.

Perhaps because he had so many commissions to paint large decorative cycles in Venice, Veronese generally avoided less lucrative categories, such as portraits, for which his contemporaries Tintoretto and Titian became better known. In spite of the fact that he did not depend upon his reputation as a portraitist, he was a very skillful one, and the size and beauty of the present example—one of the most striking of the few he undertook—indicate that it must have been a particularly important commission for him. It is executed with a painterly verve and freedom of execution that characterize all of the artist's work.

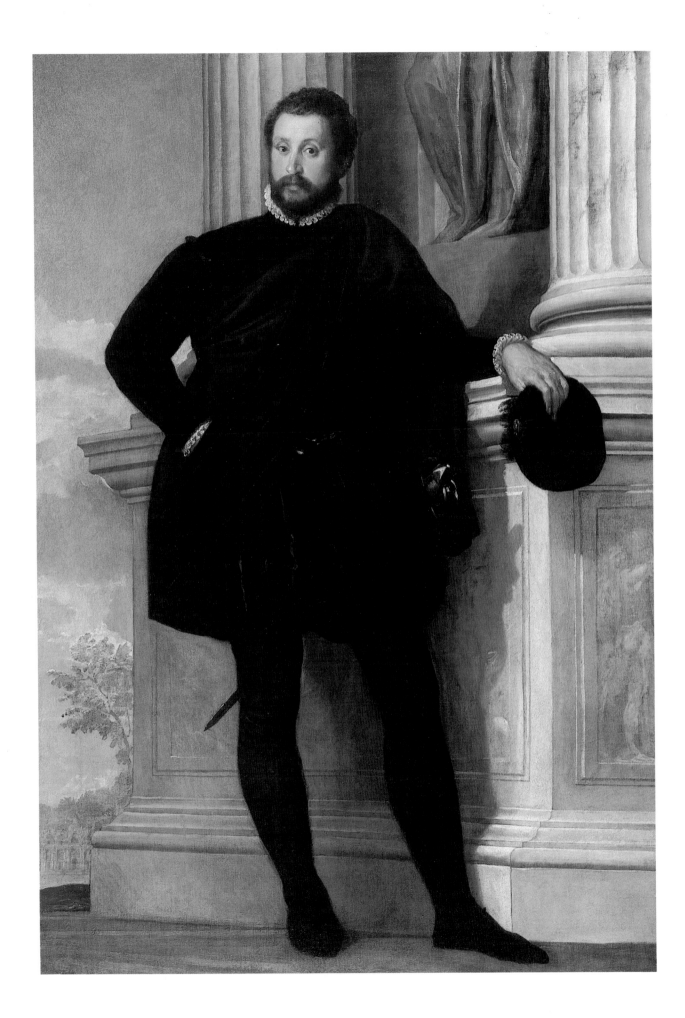

DOMENICHINO (DOMENICO ZAMPIERI)
Italian, 1581–1641
Christ Carrying the Cross, circa 1610
Oil on copper
53.7 x 68.3 cm (21⅛ x 26⅝ in.)
83.PC.373

The impetus of papal commissions and the extensive construction that took place during the sixteenth and seventeenth centuries made Rome the center of artistic activity on the Italian peninsula for the first time since antiquity. Relatively few artists involved in this resurgence were natives of the city or were trained there until later in the seventeenth century, and a tradition had developed of importing leading artists from other centers with longer- and better-established schools. In the early years of the seventeenth century, the largest number of these artists came from Bologna and were allied with the movement founded by the Carracci family, a school that flourished in central Italy for over a century.

Domenichino, who like Giovanni Lanfranco and Guido Reni (see nos. 12, 13) was a prominent member of this group, arrived in Rome in 1602. He worked closely with Annibale Carracci and over the next four decades remained one of his most loyal adherents. Domenichino's career was marked by a series of important fresco projects, but he also painted a number of religious pictures for individual patrons. During his first decade in Rome, he painted a few of these on copper, a support that was popular for small compositions requiring a high degree of finish. The Museum's copper is one of the masterpieces of this early period. It was probably executed about 1610 and is particularly indicative of the care that the artist devoted to his work.

Domenichino emphasized the careful planning of composition and individual figures, and his execution was exceptionally painstaking. Along with the Carracci, he stood in opposition to the "realist" movement led by Caravaggio and his followers (see no. 30), maintaining instead that nature must be ordered and improved upon. This stance was a rational one, and typically, *Christ Carrying the Cross* does not emphasize the Savior's suffering, in spite of the brutality of the subject. Domenichino imparted a sense of strength to his figures but eschewed dramatic exaggeration of any kind. The compression of the figures at the sides of this composition may be deliberate, or it may be in part the result of the copper panel having been trimmed at some time in the past.

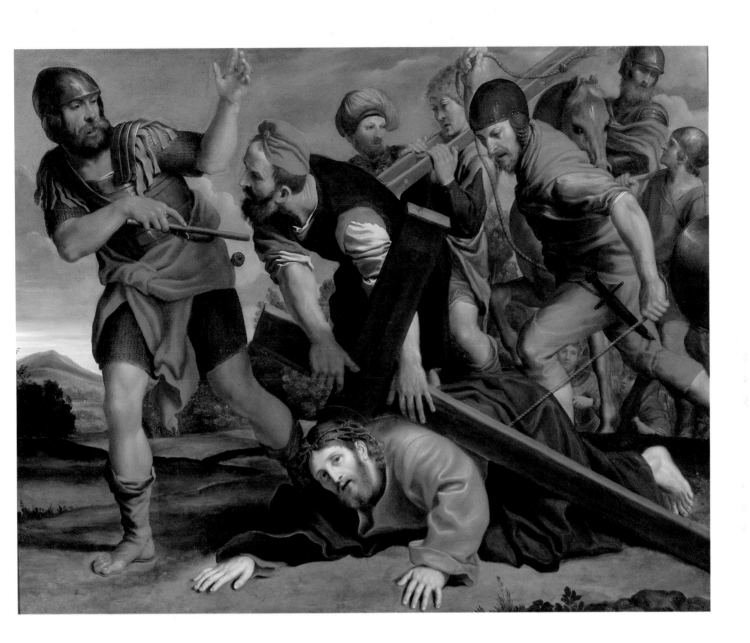

GIOVANNI LANFRANCO
Italian, 1582–1647
Moses and the Messengers from Canaan, 1621–1625
Oil on canvas
218 x 246.3 cm (85¾ x 97 in.)
69.PA.4

Giovanni Lanfranco, like Domenichino and Guido Reni (see nos. 11, 13), was one of the many Emilian, primarily Bolognese, painters who migrated to Rome in the early seventeenth century to fill the demand for pictures to decorate the many new churches and private palaces. As soon as he arrived in the mid-1610s, he was commissioned to paint a series of important decorative cycles; he was kept busy with such projects for nearly two decades. Among the largest and most prestigious of these endeavors was a series of paintings on canvas and in fresco, begun about 1621/22 and completed about 1624/25, for the church of San Paolo fuori le Mura. These paintings decorated the Cappella del Sacramento, and they were placed over the pews, well above eye level. The themes of the paintings were related to the Sacrament and events prefiguring it in the Old Testament.

The Museum's painting was one of three on the left wall of the chapel; it was located to the left of the *Last Supper* (now in the National Gallery of Ireland, Dublin) and *Elias Receiving Bread from the Widow of Sarepta* (also in the J. Paul Getty Museum). The subject of *Moses and the Messengers from Canaan* is an uncommon one, the moment when the spies sent by Moses into Canaan returned to tell him that the land bore fruit. The messengers carry pomegranates, figs, and grapes; the grapes are a key to this subject's inclusion in the series because they were seen as a prefiguration of the wine drunk at the Last Supper. In the painting of Elias and the widow of Sarepta, the bread being offered similarly relates the theme to the Last Supper and the Eucharistic elements.

It has been suggested that this series was commissioned from Lanfranco by the abbott Paolo Scotti for whose family the artist had worked previously. The paintings became famous in Rome, and the entire series was copied on more than one occasion by other artists. The composition of the present painting, with its dramatic placement of full-length and life-size figures silhouetted against a cloudy sky and the heads of other men shown emerging from behind and below, was probably the most original and impressive of the group. The vantage point of the viewer, well below the horizon, is appropriate given the placement of the paintings high up on the chapel walls. The scene is rendered with very large and boldly applied brushstrokes.

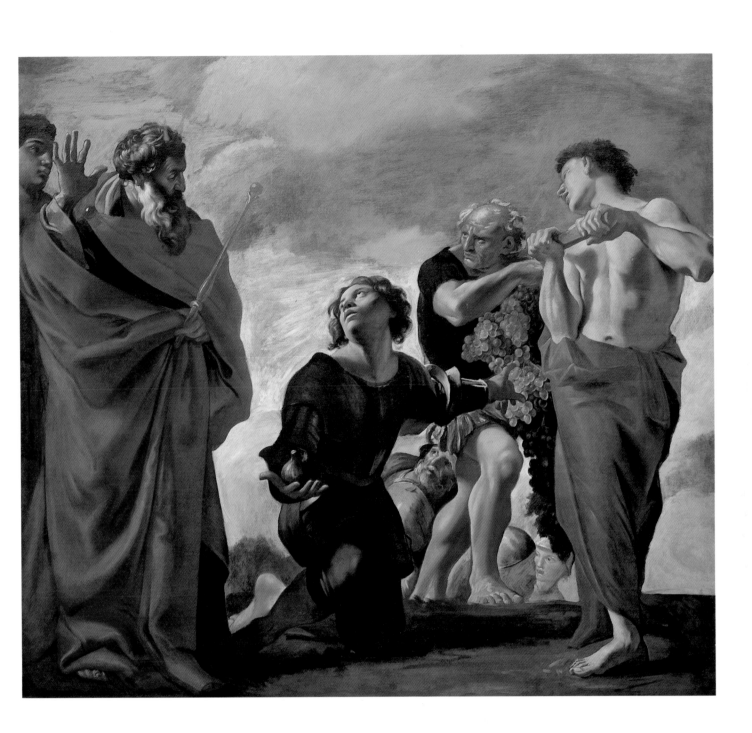

GUIDO RENI
Italian, 1575–1642
Virgin and Child with Saint John the Baptist, circa 1640–1642
Oil on canvas
172.7 x 142.3 cm (68 x 56 in.)
84.PA.122

During his lifetime Guido Reni was considered one of the most successful and gifted artists ever to have lived. Spending his career in Rome and his hometown of Bologna, he executed an unbroken series of commissions for kings, emperors, popes, the nobility, the wealthy, and numerous religious bodies. He was prolific, and his work was imitated by many of his contemporaries.

Guido's style was derived from that of the Carracci (see no. 11), under whom he was trained, but above all, he prized Raphael's work of the previous century. The painting in the Museum's collection is among his most Raphaelesque. The balance and perfection of the composition belie the rapidity with which it was executed. In contrast to the meticulous preparations that Raphael would have undertaken for such a painting, Guido has hardly more than sketched in the entire canvas, leaving some parts barely painted—such as Mary's clothing or the figure of the young Saint John at the right.

It was during the last decade of his career that Reni produced a large number of rapidly executed works such as this one. Many artists adopt a quicker technique as they grow older, and the spontaneity of such works often reveals more of the artist's nature and style than do very finished paintings.

Guido's late works are much more subdued in tone, partly because he liberally mixed large amounts of white with his pigments, producing a muted, grayish quality. He supposedly did this so that his pictures would not darken as much as those of earlier periods. According to Carlo Cesare Malvasia, the artist's seventeenth-century biographer and compatriot, "He used soft and pleasant shadows such as those produced by a clear and open light" rather than "by the light that is too artificial, too violent and affected." Malvasia was contrasting Guido's technique with that of Caravaggio and his followers (see no. 30), whose style was considered too radical in Bologna. The Museum's painting typifies Guido's skill with devotional subjects, which he permeated with a softness and calm.

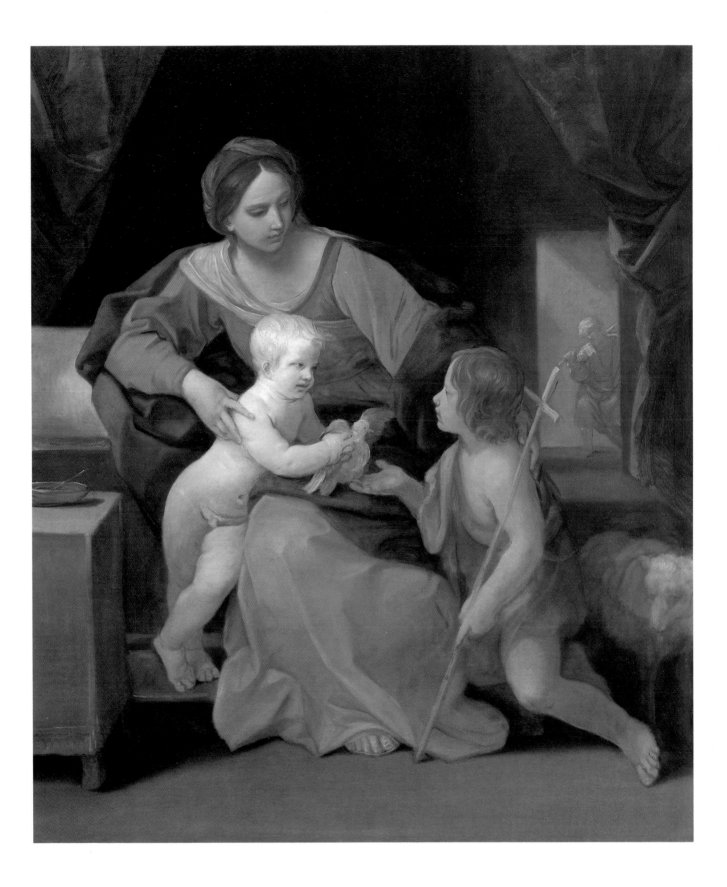

ALESSANDRO MAGNASCO
Italian, 1667–1749
Bacchanale, circa 1720–1730
Oil on canvas
118 x 148.5 cm (46½ x 58½ in.)
78.PA.1

Magnasco was raised in northern Italy at a time when academies, which had begun to flourish in many parts of Europe, were promulgating increasingly precise standards of composition and ideal beauty. He did not, however, adhere to any tradition of classical perfection, nor did he conform to the categories of style that had previously existed. (His quick and sketchy manner does, however, have parallels with that of his contemporary Francesco Guardi in Venice.) Magnasco achieved early success by painting pictures with such obvious energy and rapidity that he immediately stood out as an artist of considerable individuality. He painted religious and mythological subjects ranging from the pious to the blasphemous and genre, or everyday, subjects including monks, nuns, Jews, shipwrecks, craftsmen, thieves, soldiers, artists, gypsies, and beggars. The style is always similar, characterized by small, nervous figures that appear almost demonic in their frantic activity.

The Museum's *Bacchanale* is a pendant, or companion piece, to another canvas in the collection, *The Triumph of Love.* Elaborate ruins appear in both pictures and are probably the work of a collaborator, Clemente Spera. In the Renaissance such mythological themes had served as the opportunity to depict gods and goddesses in idyllic settings, often betraying a nostalgia for the perfection associated with the classical age. Magnasco's ruins still belong to this tradition. The figures, on the other hand, dance and swirl about on a kind of bizarre stage, lending the composition a unique atmosphere of electricity and agitation.

It has been suggested that this pair of canvases was painted for a hunting lodge because of the large number of hunting horns that are seen tied to columns and strewn about the picture. It is difficult to find any other explanation for this detail, but many of the artist's paintings contain the motif. It may be that the horns were simply intended to add to the total effect of nervous movement and frenetic revelry that typifies most of the artist's best paintings.

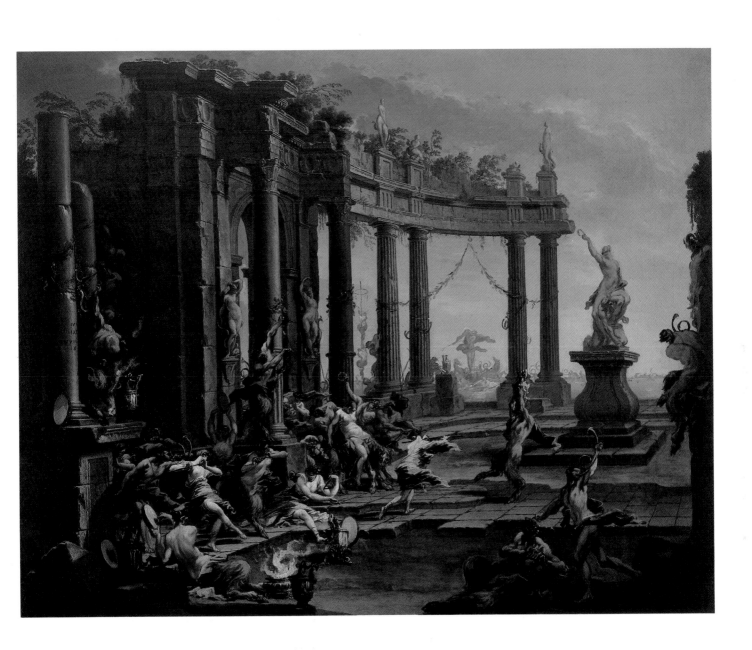

CANALETTO (GIOVANNI ANTONIO CANAL)
Italian, 1697–1768
View of the Dogana, Venice, 1744
Oil on canvas
60.3 x 96 cm (23¾ x 37¾ in.)
At bottom left, signed *Ant. Canal Fecit. MDCCXLIV*
83.PA.13

The composition of this painting focuses on the Punta della Dogana in Venice, the site of the customs house on the point of land guarding the entrance to the Grand Canal at the right. Behind it looms the dome of the church of Santa Maria della Salute. In spite of the Dogana's modest size and odd design, it appears in many paintings by Canaletto and other artists because of its prominent location. Another and perhaps more important reason for the choice of site in the present painting can be seen just to the left of the Dogana: a docked schooner flying an English flag. The importance given this boat and the unusual inclusion of a foreign standard strongly suggest that the view was commissioned by an Englishman. Most of Canaletto's customers at this time were English, and his popularity among this clientele was so great that in 1746 he traveled to England and remained there for a full decade.

Beginning in the late 1730s, Canaletto's most important client was Joseph Smith, the English consul in Venice, who for a time had exclusive rights to his production. Most of the paintings done for Smith are signed and dated 1742 and 1744. It appears as though during this period Smith may have insisted that the artist authenticate his pictures by signing and dating them—Canaletto did not normally do so—perhaps as a precaution against the many imitations of the artist's work that were already in circulation. It is possible that the *View of the Dogana* was painted for Smith.

During this phase of his career Canaletto produced his best paintings. He had long since perfected his technique of painting architectural views: a combination of studies made on the spot with a camera obscura (a boxlike device used to make accurate drawings) and later painted in the studio with a variety of mechanical devices such as compasses, dividers, and straight edges. In today's terms his methods were closest to those of the architectural draughtsman who prepares a view of a proposed building for a client. But the degree of detail Canaletto incorporated and his ability to reproduce the city in all its splendor made his paintings much more than simple records. Indeed, for more than a century his views influenced the way in which most of the world thought of Venice.

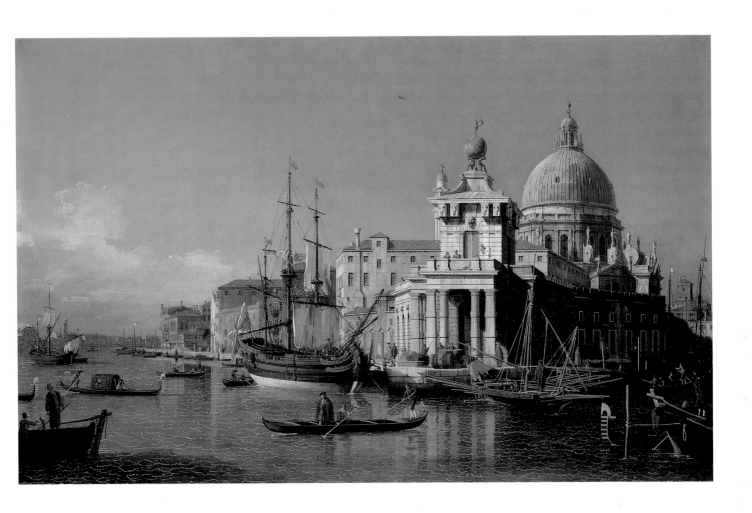

DIERIC BOUTS
Flemish, active circa 1445–died 1475
The Annunciation, circa 1450–1455
Distemper on canvas
90 x 74.5 cm (35 7/16 x 29 3/8 in.)
85.PA.24

The Annunciation belongs to a set of five paintings that originally constituted a polyptych—an altarpiece that evidently consisted of an upright central section flanked on each side by two pictures, one above the other. The other scenes in this series have been identified as the *Adoration of the Magi* (private collection), *Entombment* (National Gallery, London), *Resurrection* (Norton Simon Museum, Pasadena), and probably the *Crucifixion* in the center (perhaps the painting now in the Musées Royaux d'Art et d'Histoire, Brussels). Because the Getty painting depicts the earliest scene in the life of Christ, it was probably placed at the top left-hand corner of the altarpiece.

Dieric Bouts was active in Louvain (in present-day Belgium) during all of his mature life. He was the most distinguished of the artists who followed in the footsteps of Jan van Eyck (active 1422–died 1441) and Rogier van der Weyden (1399/1400–1464), although much less is known about his life and relatively few of his paintings survive. His style was generally more austere than that of his contemporaries, and his work consistently projects a sense of restraint. It is also typified by great precision.

In *The Annunciation*, the artist has provided a typically convincing sense of space and has gone beyond his predecessors in allowing us to feel the character of Mary's private chamber. It is a relatively colorless sanctuary, much like the cells inhabited by the monks and nuns who normally commissioned and lived with such altarpieces. The exception to this austerity is the brilliant red canopy over the bench behind Mary. The symbolic lily, normally present in depictions of this scene, has been omitted, and the conventionally colorful floor tiles are much subdued. The Virgin wears a grayish mantle rather than the usual deep blue, and Gabriel is dressed in white, not the highly ornamented clothing usually worn by archangels. Such details were often stipulated in advance by the ecclesiastics who commissioned a work, and in these departures from tradition, a message is probably being conveyed that had particular significance for the institution in which the altarpiece was to be seen.

The Annunciation, like the other sections of the altarpiece, was painted on linen rather than wood. This was sometimes done to make a painting more portable, but it is highly unusual for a polyptych of this size.

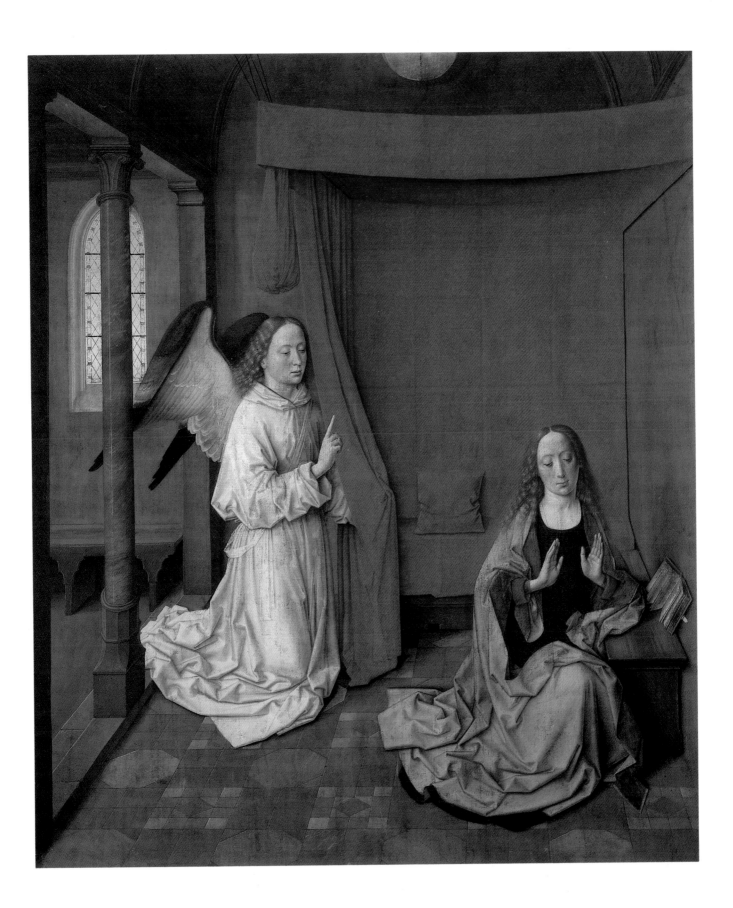

JOACHIM WTEWAEL
Dutch, 1566–1638
Mars and Venus Surprised by the Gods, circa 1604
Oil on copper
20.3 x 15.5 cm (8 x 6⅛ in.)
At bottom right, signed *JOACHIM WTEN/WAEL FECIT*
83.PC.274

This enchanting painting on copper, one of the Museum's smallest and most precious, depicts a story from Ovid's *Metamorphoses* in which Vulcan, in the company of other gods, surprises his wife, Venus, in bed with Mars. Vulcan on the right removes the net of bronze, which he had forged to trap the adulterous pair, while Cupid and Apollo hover above, drawing back the canopy. Mercury, standing near Vulcan, looks up gleefully toward Diana while Saturn, sitting on the cloud near her, smiles wickedly as he gazes down on the cuckolded husband. Jupiter, in the sky at the top, appears to have just arrived. Through an opening in the bed hangings Vulcan can be seen a second time in the act of forging his net.

Mythological themes of this kind were especially popular during the sixteenth century, when interest in the classical world reached a peak. The present rendering of the infamous legend of Mars and Venus exemplifies the Dutch fascination with human misbehavior, particularly scenes of lecherous misconduct. Wtewael here anticipates the earthy humor of the later seventeenth century—normally focused upon peasants—for which his countrymen became famous.

The use of copper as a support for paintings was especially widespread during the late sixteenth and early seventeenth centuries. The very hard and polished surface lent itself to small, highly finished and detailed pictures. Wtewael worked equally well in both large and small scale and on canvas as well as copper. Copper was well suited for the present picture, since it allowed for subtler gradations of tone and greater intensity of color than canvas. Fortunately, the painting is in perfect condition and virtually as brilliant as the day it was painted. Due to the erotic subject matter, it may have been kept hidden, and hence protected, over the years.

In his famous treatise on art, *Het Schilder-boeck*, published in 1604, the Dutch writer Karel van Mander reports that Wtewael had painted two tiny coppers of this subject, one of which had been done very recently. The two pictures are thought to be the Museum's *Mars and Venus* and another similar work now in the Mauritshuis in The Hague, which is dated 1601. The Museum's painting was probably the one commissioned for Joan van Weely, a jeweler from Amsterdam.

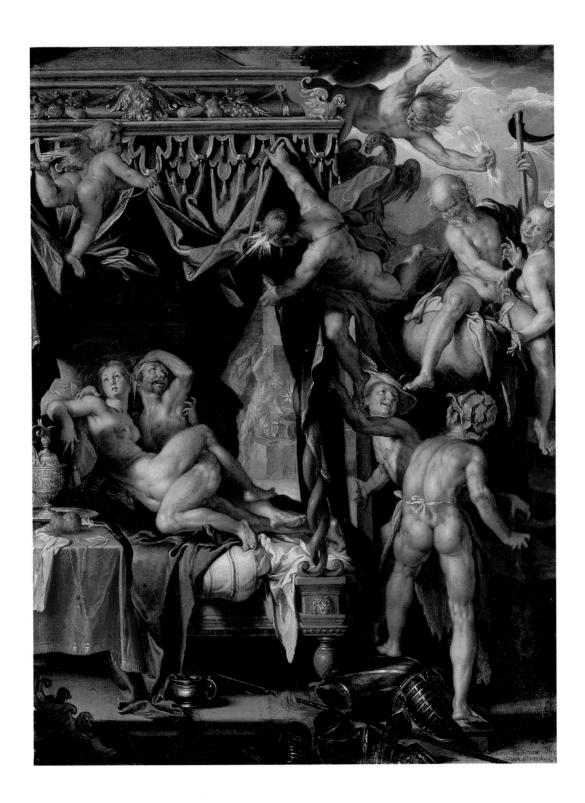

AMBROSIUS BOSSCHAERT THE ELDER
Dutch, 1573–1621
Basket of Flowers, 1614
Oil on copper
28.6 x 38.1 cm (11¼ x 15 in.)
At bottom left, signed .*AB.1614.*
83.PC.386

Paintings of floral still lifes began to appear at the very end of the sixteenth century in both the Low Countries and Germany and were linked to a rising interest in botany. Herbals, books describing plants and their properties, were popular reading at the time, and they usually contained illustrations. Furthermore, the collecting of different types of flowers, already a passion among the Dutch, became virtually a national pastime during the course of the seventeenth century (see no. 29).

Although early examples of flower still lifes appeared in Amsterdam and Antwerp, the center of production was Middelburg, an important seaport and trading center and the capital of the province of Zeeland. The school's founder was Ambrosius Bosschaert, an immigrant from Antwerp, who had moved to Middelburg with his family to escape Catholic persecution. By 1593 Bosschaert was already a respected artist in Middelburg, and as far as is known, his entire career was dedicated to still-life painting. Members of his immediate family followed in his footsteps and established a tradition that flourished until after the mid-seventeenth century. It is also known that Bosschaert dealt in pictures, which he sent to other parts of the Netherlands and also to England. His considerable influence has only recently been recognized.

Still lifes often had symbolic or religious connotations, and flowers were sometimes employed to represent the transitoriness of life or to allude to salvation and redemption. The Museum's still life, painted on copper (see no. 17), contains a basket of flowers with a dragonfly resting on the table nearby and a butterfly perched on a tulip. A caterpillar and a bumblebee are also depicted. If the composition at one time suggested a specific meaning to the viewer, it has been lost to us. We can appreciate, however, the freshness of the flowers and the delicate rendering of detail. As was often the case, the picture contains a number of flowers that could not have bloomed during the same season: roses, forget-me-nots, lilies of the valley, a cyclamen, a violet, a hyacinth, and, of course, tulips. All are arranged in a straightforward and simple manner, with the basket in the center and the single flowers laid out parallel to the picture plane. Already very expensive at the time they were painted, such pictures were beyond the reach of the average citizen.

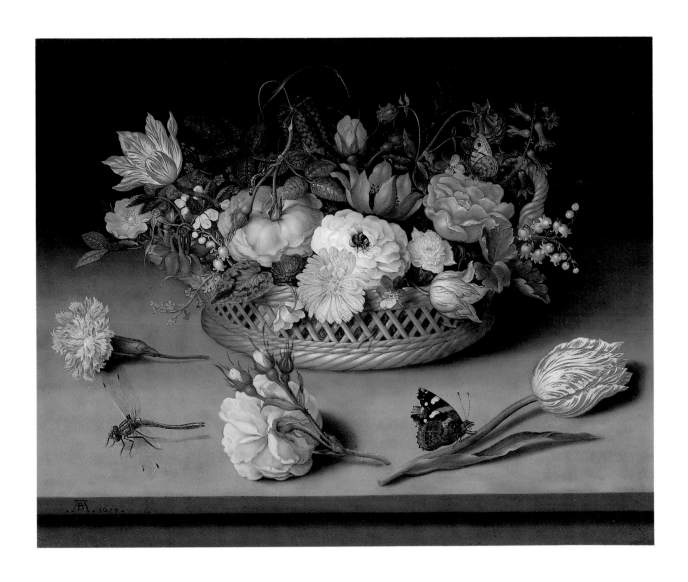

ANTHONY VAN DYCK
Flemish, 1599–1641
Portrait of Agostino Pallavicini, 1621
Oil on canvas
216 x 141 cm (85⅛ x 55½ in.)
At top right, near back of chair, signed *Ant^{us} Van Dyck fecit.*
68.PA.2

Van Dyck's reputation as an artist was already beginning to spread throughout Europe when he traveled to Italy in 1621. He initially went to Genoa, where Flemish contacts had been established for two centuries, largely because the Genoese had strong commercial ties to Antwerp, van Dyck's home. He remained in Italy for five years, traveling about to view large private collections of Italian paintings, and during this time he was extensively employed to paint portraits. It was in Genoa, however, that van Dyck experienced his greatest successes and executed some of his most famous and impressive paintings.

The Museum's portrait depicts a member of the Genoese branch of the Pallavicini family, whose coat of arms may be seen on the drapery to the left, behind the sitter. He is shown in flowing red robes, which almost become the focus of the painting. In his hand he holds a letter; at one time this must have identified him, but it is no longer legible. From other documented portraits, however, it can be established that this is Agostino Pallavicini (1577–1649). The writer Giovanni Pietro Bellori, who in 1672 described van Dyck's stay in Genoa, relates that the artist painted "His Serene Highness the Doge Pallavicini in the costume of Ambassador to the Pope." Pallavicini was not made the doge (the chief magistrate of the Genoese republic) until 1637, but he was sent to Rome to pay homage to the recently elected Pope Gregory XV in 1621, and it is in this capacity that we see him. Thus, the Museum's painting is one of the first executed by van Dyck after his arrival in Italy.

Our present-day image of seventeenth-century Genoese nobility owes more to van Dyck than to any other artist, and the Museum's painting typifies the grandeur and stateliness of his portraits. They are usually life-size and full-length with a background of pillars and swirling, luxurious draperies. At the time, no other artist in Italy could produce the same grand effect, and the result so enthralled the European nobility that van Dyck's style eventually set the standard for portraiture in Italy, England, and Flanders.

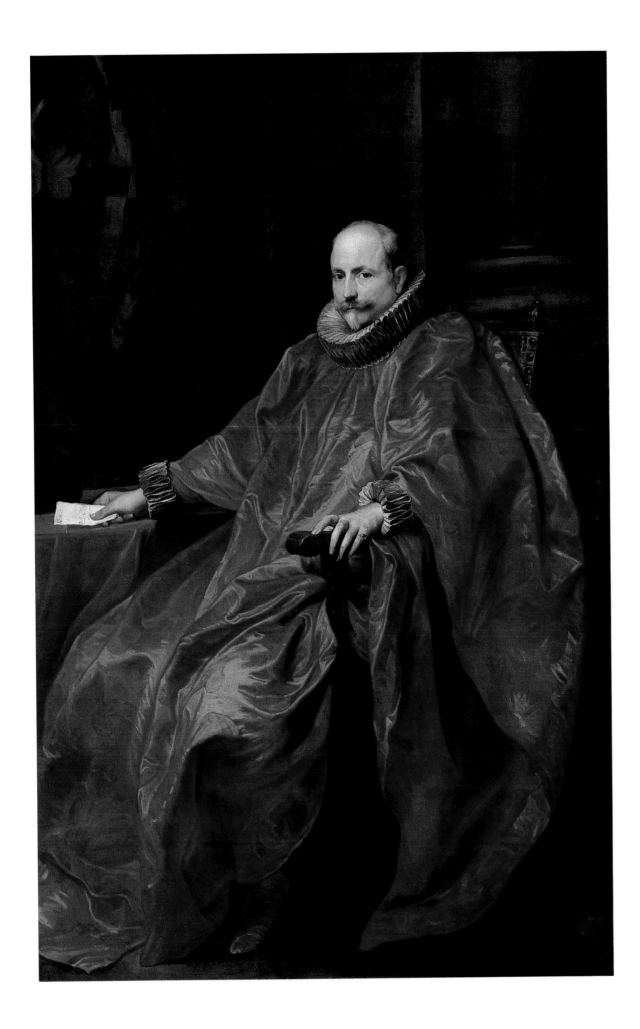

HENDRICK TER BRUGGHEN
Dutch, 1588–1629
Woman with an Ape: Allegory of Taste(?), 1627
Oil on canvas
102.9 x 90.1 cm (40½ x 35½ in.)
At center right, signed *H^TBrugghen fecit 1627*
84.PA.5

Of all the cities in the predominantly Protestant Netherlands, Utrecht, which had remained the most Catholic in orientation, maintained the closest ties with Italy. Many Dutch artists made the pilgrimage to Italy during the seventeenth century, but those from Utrecht, following a tradition established a century earlier, always showed the greatest stylistic affinity with their Italian colleagues.

Ter Brugghen came from Utrecht and was one of the most important links in this tradition. While in Rome from circa 1604 to 1614, he saw the works of Caravaggio, whose new sense of "realism" held a great fascination for him (see no. 30). Ter Brugghen adopted some of the Italian artist's lighting effects and compositional methods in his own work. His technique, however, which was typified by unusual combinations of colors, often pastels, remained very much his own.

The sitter's pose and the composition of the Museum's painting were almost certainly inspired by two famous depictions of Bacchus, the Greek god of wine, by Caravaggio. Ter Brugghen would have seen these paintings in Rome. In each case the subject is shown half-length and holding grapes. All three figures are rendered with strikingly individual features and a demeanor suggestive of playfulness.

The woman in this painting has traditionally been identified as a bacchante, a follower of Bacchus. She is shown squeezing grapes into a chalice, but she lacks the wreath of vine leaves and other traditional attributes of the deity's disciples. There are some vine leaves on the table in the foreground, as well as a walnut, a pear, and an ape, but they seem almost incidental. The smiling lady's heavy clothing also implies that she occupied a climate too cold to have been hospitable for Bacchic revels. Monkeys or apes are often found in allegories of the sense of taste. However, allegories of the senses were usually depicted in sets representing all five, and no other such painting by ter Brugghen is known. In any case the subject is unique, as the vast majority of the artist's works concentrates upon religious subjects or themes drawn from everyday life.

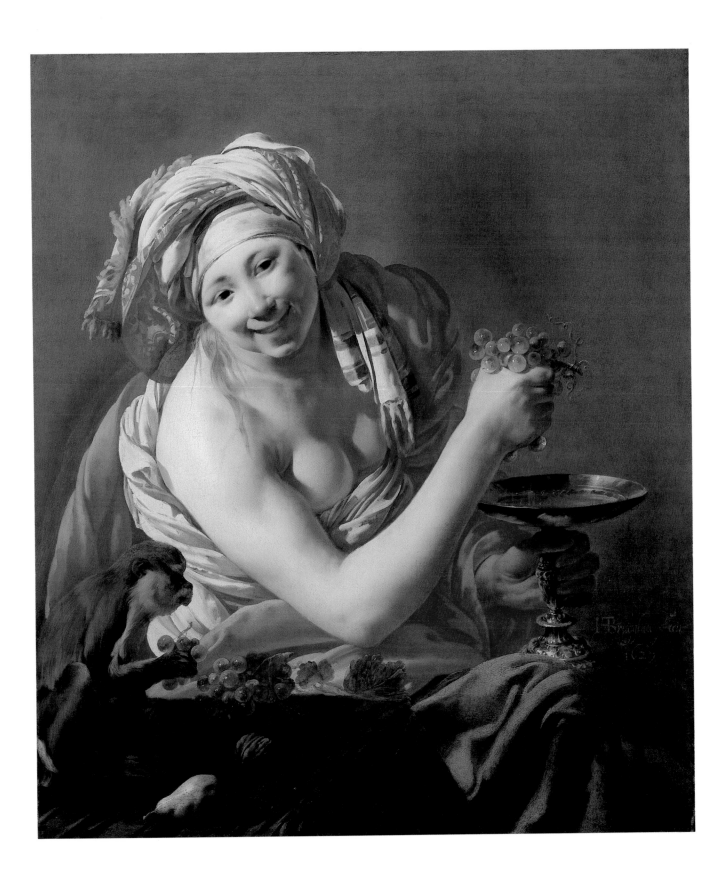

PIETER JANSZ. SAENREDAM
Dutch, 1597–1665
Interior of the Church of Saint Bavo, Haarlem, 1628
Oil on panel
38.5 x 47.5 cm (15⅛ x 18¾ in.)
At bottom right, signed *P. SAENREDAM F. AD 1628*
85.PB.225

The architectural interior was one of the specialized themes developed by the painters of the Low Countries. First practiced in sixteenth-century Antwerp, architectural painting was raised to a highly refined profession by a number of Dutch artists who restricted themselves to this genre. They concentrated on the depiction of churches, which in the Netherlands were relatively unadorned and reflected a rather austere approach not only to religion but to life itself.

Saenredam is credited with having begun the tradition in the Netherlands and having given it a specifically Dutch character and a more "realistic" direction. The earlier Flemish architectural views had largely been exercises in the newly perfected technique of perspective, and the buildings depicted were usually inventions. Trained as an architectural draughtsman, during the mid-1620s Saenredam worked for Jacob van Campen, the leading Dutch architect, himself an accomplished perspectivist. The present painting, inscribed 1628, is the earliest dated example of Saenredam's work. It is the first of a series of paintings and drawings of Saint Bavo's church in Haarlem, the city in which the artist made his home.

Rather than sketching churches from the nave (the long central hall), Saenredam often stood at more obscure vantage points. He then worked up a finished cartoon, or design, which he transferred directly to a prepared panel. He often made adjustments to the composition, altering architectural details or proportions. One of the two preparatory drawings for the Museum's painting that survive reveals the artist's decision to eliminate three doors at the rear of the transept and replace them with a painted altarpiece. He also rounded the Gothic arches at the sides and added some stained glass. Despite these modifications, the subtle, almost monochromatic coloring, atmosphere, and general flavor of the picture convey a more accurate impression of what it was like to visit a Dutch church than had ever before existed.

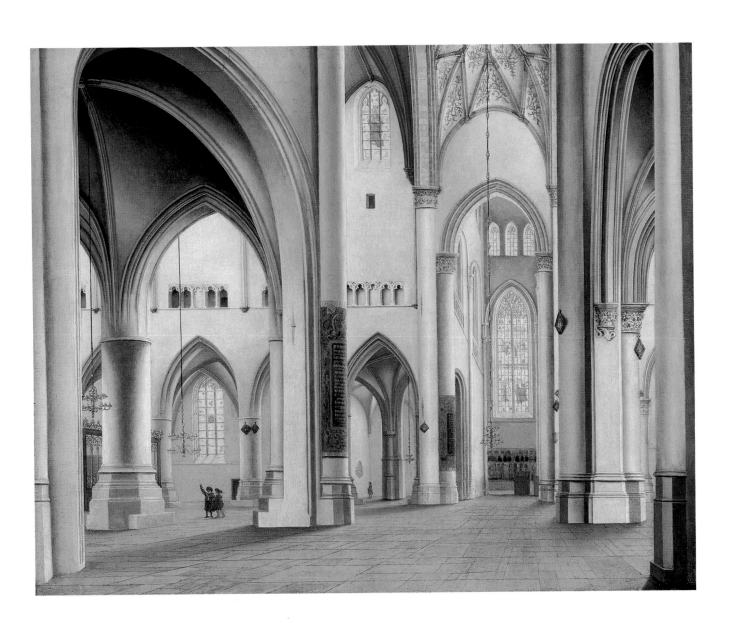

REMBRANDT VAN RIJN
Dutch, 1606–1669
An Old Man in a Military Costume, circa 1630
Oil on panel
66 x 50.8 cm (26 x 20 in.)
At top right, signed *Rembrandt f.*
78.PB.246

The style of this undated painting indicates that it was executed circa 1630 when the artist was still in his early twenties. The sitter, who appears in a number of paintings and compositions by Rembrandt and other artists working in his circle, was assumed for a long time to be Rembrandt's father. This identification is now doubted, but the man was in any case a model well known to this group of painters and obviously did not commission or pay for his portrait. In this instance Rembrandt used him as a subject for experiment, placing a beret on his head and adding a feather for effect. A metal gorget, the throat-piece from a suit of armor, was fastened around the sitter's neck so that the artist could observe the play of light on a smooth, shiny surface. This costume, concocted by Rembrandt, provided a variety of textures and increased the dramatic effect of the pose. The wispy mustache and stubbly beard contribute to the subject's individuality.

Although one might argue that such starkly dramatic busts probably served to prepare the artist for pictures containing soldiers or featuring similar light effects, they were more than studies. Their novelty and intensity, combined with bold brushwork and stark lighting, quickly attracted the attention of both connoisseurs and painters throughout Europe. These busts achieved a popularity of their own and became the subject of many etchings and imitations.

Soon after painting this bust and having achieved a certain success in Amsterdam, Rembrandt settled into a career of painting portraits and subject pictures. Dramatic lighting remained a hallmark of his work, and he never ceased to experiment with ways in which to apply paint to canvas or panel (see no. 25). The more obvious props, however, and the slightly exotic element slowly disappeared from his work as the artist matured and found quicker and less meticulous solutions to generate the effects he desired. His paintings continued to suggest that they looked more deeply into the nature of the sitter than ever before—or since.

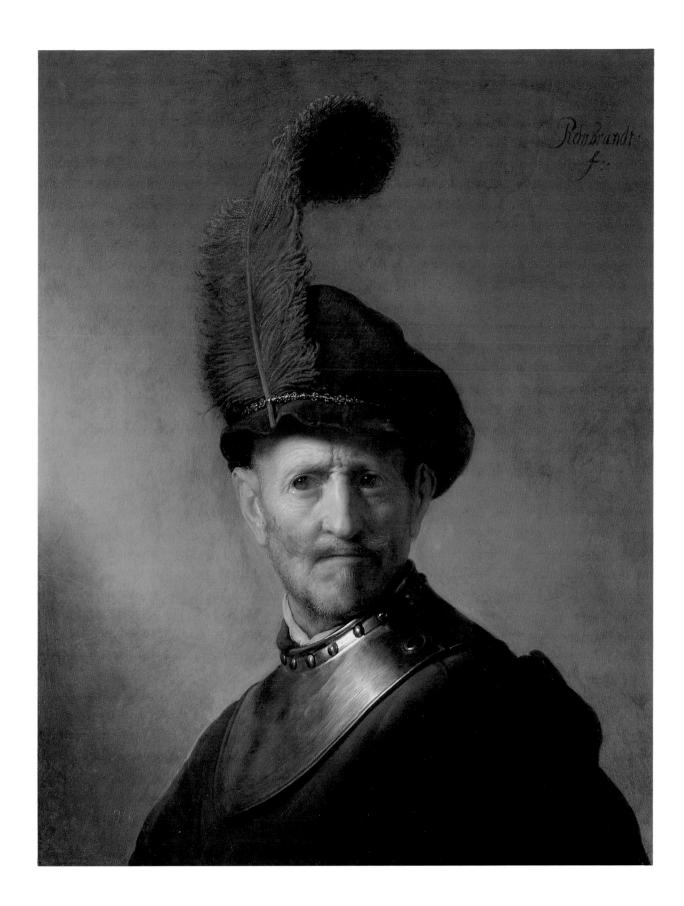

GERRIT DOU
Dutch, 1613–1675
Prince Rupert of the Palatinate and a Tutor as Eli and Samuel(?), circa 1631
Oil on canvas
102.9 x 88.3 cm (40½ x 34¾ in.)
84.PA.570

Although he briefly studied under painters in Amsterdam, Rembrandt, the most influential Dutch artist of all time (see nos. 22, 25), established his reputation and achieved his first successes in his birthplace, the town of Leiden. He remained there until the age of twenty-five. From 1628 to 1631/32, the years just before his departure, he was joined in a kind of partnership by two exceptional artists, also natives of Leiden: Jan Lievensz., who was just a year younger, and Gerrit Dou, seven years Rembrandt's junior. Working together, the three painters produced many works of astonishing originality. Rembrandt is now credited with having been the driving force behind this atelier, but at the time the other two artists were considered by critics to be virtually his equals.

The sitter in this painting has been traditionally described as one of the two sons of Elizabeth of Bohemia and her husband, Frederick v, Elector Palatine. He is now thought to have been Prince Rupert. His brother, Prince Charles Louis, is depicted in the companion piece to this painting, executed by Lievensz. (also in the J. Paul Getty Museum). The princes were students at the university in Leiden when these portraits were painted in 1631, the year inscribed on Lievensz.'s canvas. This was the time of Rembrandt's departure from his birthplace and perhaps explains why the commission was given to his two colleagues. The students, both seen with their tutors, have been depicted as historical figures, and in the case of Dou's portrait, it is thought that Eli and Samuel, from the Book of Samuel, are intended. The Dutch Protestants of this time felt a strong affinity with the Israelites and favored subjects from the Old Testament; hence, the parallel that Dou has drawn to prominent biblical personages. The companion piece by Lievensz., however, evidently portrays its sitters as classical figures.

Dou was somewhat more meticulous in technique than Rembrandt, having worked with two glass engravers before taking up painting. In this early phase, however, he was remarkably painterly, and in many details the Museum's painting could be mistaken for the work of Rembrandt (see no. 22). It was in fact attributed to the older artist until fairly recent times.

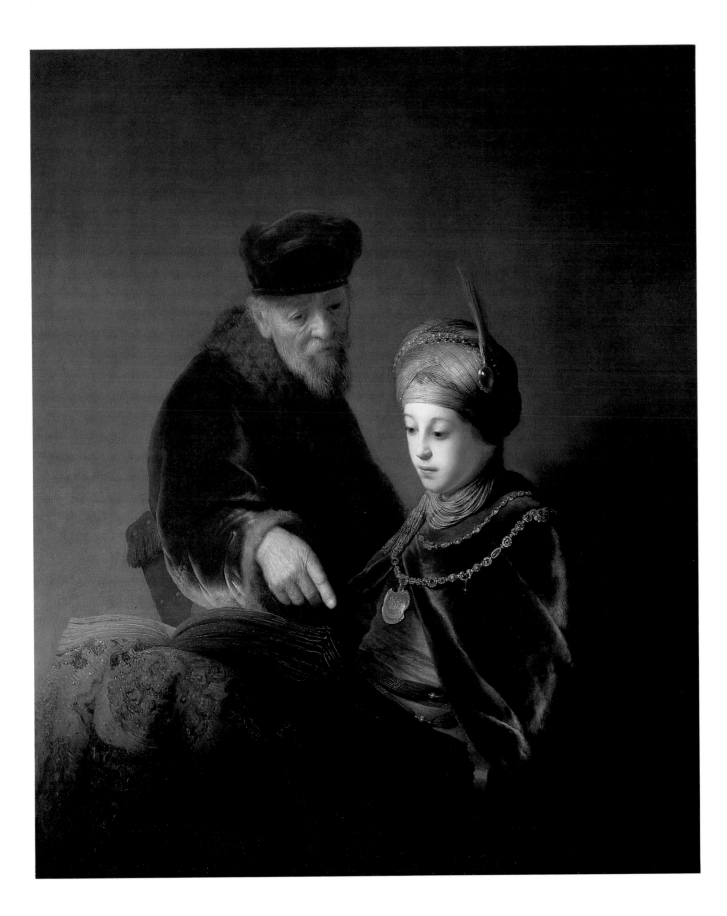

JACOB VAN RUISDAEL
Dutch, 1628/29–1682
Two Water Mills and an Open Sluice, 1653
Oil on canvas
66 x 84.5 cm (26 x 33¼ in.)
At bottom left, signed *JVR* [in monogram] *1653*
82.PA.18

Since the seventeenth century Jacob van Ruisdael has been recognized as the Low Countries' most important landscape painter and credited with transforming the tradition of landscape painting into one based more closely on the observation of natural detail. He had already established his reputation at the age of nineteen, and the present painting, executed when he was scarcely twenty-five, is a strong indication of how rapidly his style matured.

During the early 1650s Ruisdael made a trip to Westphalia (located in present-day West Germany), as far as is known the longest trip he ever made from his hometown of Haarlem. En route, he apparently saw some water mills at Singraven, a town in the Dutch province of Overijssel. Subsequently, he painted a series of views of these mills; the Museum's canvas is one of six known variations and the only one that is dated. A comparison of the six versions reveals that the artist did not hesitate to rearrange the setting and some details of the mills in order to enhance his composition. While the general appearance of the rough buildings remained the same, Ruisdael felt free to add small sheds on the side or to alter the shape of the roof and give it a different profile. Similarly, he moved trees around and added hills—such as the one at the right between the two mills in the Museum's landscape—to lend variety to the topography, which in reality was flat. Ruisdael preferred this way of working during this phase of his career, and although his views are topographically accurate in many respects and indicate a close study of nature, he did not consider himself bound to represent every landscape element exactly as it would have appeared.

Later in life he helped satisfy the popular demand for more exotic landscapes by painting views of waterfalls—evidently inspired by paintings and drawings of Scandinavia. These works drew more heavily upon the artist's imagination. Initially, however, he felt relatively more constrained to paint what he saw. The Museum's painting is a rendering of one of the few sites where Ruisdael might have actually seen rushing water. It is a marvelously atmospheric depiction, which the artist made even more lively with his skillful brushwork.

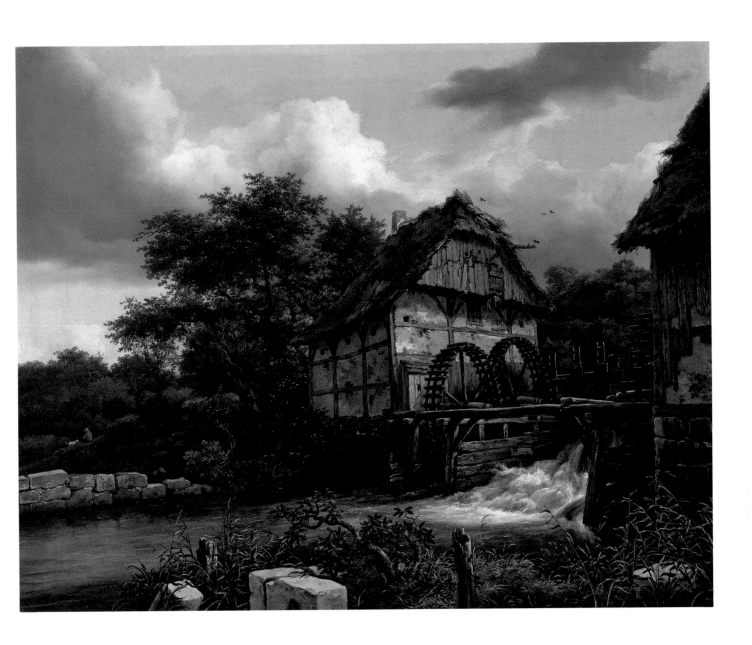

REMBRANDT VAN RIJN
Dutch, 1606–1669
Saint Bartholomew, 1661
Oil on canvas
86.5 x 75.5 cm (34 ⅛ x 29 ¾ in.)
At bottom right, signed *Rembrandt / f.1661*
71.PA.15

The present painting is one of a series of portraits of the apostles that bear the date 1661. The portraits were apparently not meant to be hung together as they are of varying sizes, and it is unlikely that the artist ever depicted all twelve of Christ's disciples. The existence of this series suggests that Rembrandt was perhaps personally preoccupied with the apostles' significance at this time, just eight years prior to his death.

Each of the known portraits gives the impression of having been painted from a model, probably a friend or neighbor, a practice that Rembrandt normally followed. The idea that a common man could be identified with a biblical personage and thereby lend a greater immediacy to Christ's teachings would have been in keeping with the religious atmosphere in Amsterdam at the time. Saint Bartholomew is represented with a mustache and a broad, slightly puzzled face. The stolid, rather pensive, and very ordinary men that Rembrandt often chose as models for these paintings would not be precisely identifiable as individual saints were it not for the objects they hold in their hands—in this case a knife, a traditional attribute referring to the fact that Bartholomew was flayed alive (see no. 4). Their clothing, which in its simplicity is meant to connote biblical times, is very different from the crisp collars and suits worn by the seventeenth-century Dutch upper classes.

Saint Bartholomew is rendered in the broader, freer style of the artist's late maturity (compare no. 22, which is a youthful work). He has used palette knives and the blunt end of his brushes in depicting Saint Bartholomew, and his technique is much more direct than that of any of his contemporaries.

The history of the interpretation of the Museum's painting is of some interest. In the eighteenth century it was thought to depict Rembrandt's cook, in keeping with the taste for everyday subjects, especially servants and humble occupations, that characterized French art of the time. In the nineteenth century, a period enamored of dramatic or tragic themes, the saint was thought to be an assassin, a reading to which the knife and the subject's intense look no doubt contributed.

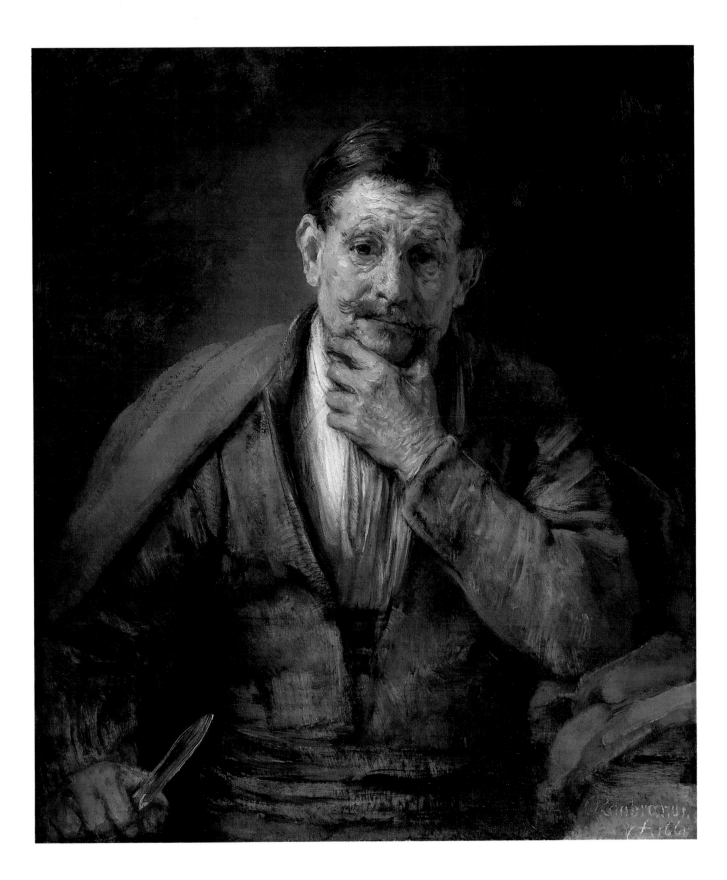

PIETER DE HOOCH
Dutch, 1629–1684
A Woman Preparing Bread and Butter for a Boy, circa 1660–1663
Oil on canvas
68.3 x 53 cm (26⅞ x 20⅞ in.)
On foot warmer, signed *P. de hooch*
84.PA.47

The education of children became an important issue in Protestant countries during the seventeenth century, and the Dutch republic was the first to succeed in establishing a universal educational system. The Dutch were proud of their schools, and already in the late sixteenth century foreigners were aware that the Dutch were teaching even farmers and peasants to read and write. Dutch paintings are full of references to the proper manner in which to bring up children, and compositions that appear to us to be simple depictions of domestic life are often also intended to instill a correct attitude toward child-rearing.

The present painting depicts a mother buttering bread while her young son stands next to her saying grace, an obligatory prayer for children that is often depicted in paintings. He is apparently about to depart for his school, which can be seen across the street labeled with a sign reading *schole*. A major theme of the painting would therefore seem to be the correct behavior and education of a boy from the middle class.

The presence of a small top lying on the floor in front of the doorway is significant. To the Dutch, tops, which fall idle unless one continually "whips" them, became an emblem for the belief that sparing the rod spoiled the child. To the Protestant way of thinking, too much idleness only led to temptation and vice, and the small top underlines the necessity of sending the boy to school.

The Museum's painting is usually dated between 1660 and 1663, about the time de Hooch moved from Delft to Amsterdam. In his earlier paintings he often included soldiers, and the homes he depicted were modest in their decoration. The interiors he painted, especially after his move, became increasingly lavish and luxurious, perhaps reflecting the higher living standards he encountered in Amsterdam or his acceptance by wealthier patrons. The interior seen here is still relatively simple, but it displays the precision and complex geometry that de Hooch characteristically brought to his compositions, traits that emphasized the rectitude revered by the society in which he worked.

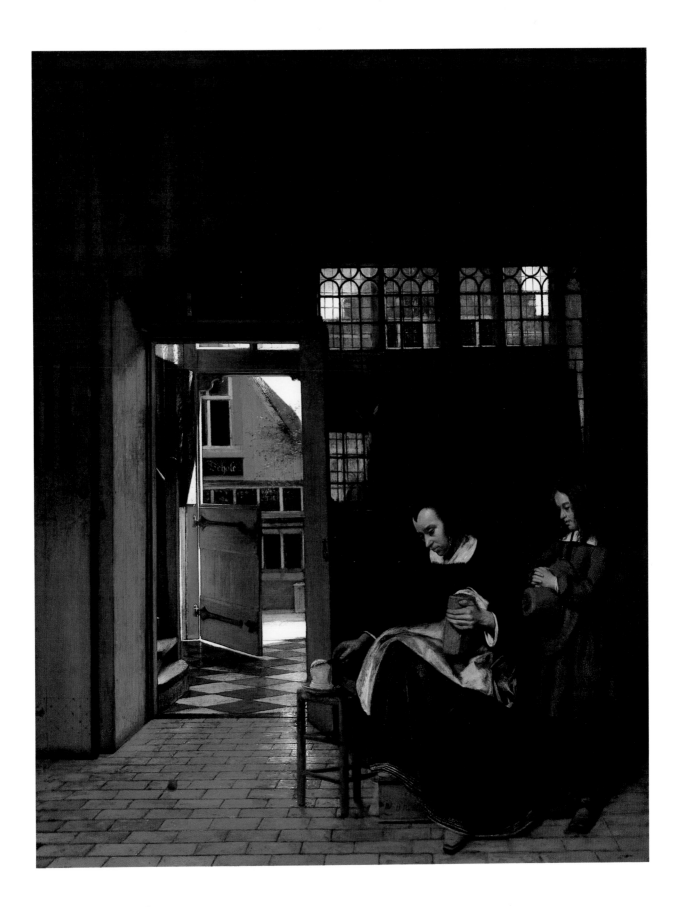

JAN STEEN
Dutch, 1626–1679
The Drawing Lesson, circa 1663
Oil on panel
49.3 x 41 cm (19⅜ x 16¼ in.)
At bottom left, signed *JStein* [the first two letters in monogram and the last three
letters uncertain]
83.PB.388

The Drawing Lesson appears to be, at least on one level, a touching family scene.
An artist, who bears a strong resemblance to known portraits of Jan Steen, demonstrates
drawing to a young boy and a teenage girl. It has been suggested that these are Steen's own
children, Cornelius and Eva. The painting also presents an unusually detailed view of an
artist's studio. On the table are brushes, pens, and charcoal pencils. Hanging over the table's
edge is a woodcut by the Dutch artist Jan Lievensz. (see no. 23) depicting the head of an old
man and dating from about thirty years earlier. Next to the drawing stand is a plaster cast
of a male nude, and hanging from the wall, shelf, and ceiling are a number of other plasters.
Also on the shelf is a sculpture of an ox, the symbol of Saint Luke, the patron saint of painters
(see no. 1). In the background is an easel with a painting on it and a violin hanging on the
wall. In the foreground is a stretched canvas, an album of drawings or prints, a carpet, a chest,
and other objects that might be used in a still life.

Some of the objects in the foreground—a laurel wreath, a skull, wine, a fur muff,
a book, a lute, and a pipe—are related to the traditional theme of *vanitas* (vanity), which is
often found in Dutch still lifes. Steen did not paint still lifes as such, and the grouping
together of so many of these objects suggests that their presence is more than accidental.
In fact, he is most famous for his depictions of human foibles and misconduct and often
portrayed himself and others as drinkers or boastful fools. He rarely failed to point out the
vanity of this behavior, however. The accumulation of so many traditional symbols of
worldly conceit in *The Drawing Lesson* may indicate that Steen felt the artist's role at
least in part to be that of a social commentator. The Museum's painting becomes, therefore,
a kind of allegory of his own profession.

The Drawing Lesson has survived to this day in remarkable condition. It is rare for
a panel painting to have escaped drastic and damaging cleanings, and the detail and subtleties
of this composition, which are present to a degree rarely found in the artist's work, are all
very much intact.

PHILIPS KONINCK
Dutch, 1619–1688
Panoramic Landscape, 1665
Oil on canvas
138.4 x 167 cm (54½ x 65½ in.)
At bottom right, signed *P Koninck 1665*
85.PA.32

During the seventeenth century, Dutch artists specialized to an almost unprecedented degree, and most of them attempted the refinement of just one or perhaps two subjects. More painters were devoted to the art of landscape painting than any other, and within this genre each artist had his own specialty—for example, forest scenes, cityscapes, or Italian views.

Perhaps the most unusual of these landscape types was the panoramic view. While Dutch art in general is noted for its love of nature and close observation of naturalistic detail, the panoramic landscape generally assumes a point of view high above the earth, as if the artist were at the top of an isolated vantage point from which he could see the otherwise flat landscape stretching away to the horizon. Because the artist in Holland had no such vantage point (with the possible exception of church towers and ships' masts), he was forced to imagine the entire scene. The clouds, of course, could be painted from any spot, but even the clouds tend to be highly picturesque in such views and are probably the result of considerable invention.

Panoramic landscapes were painted in the sixteenth century but were never plentiful in number. The idea was revived by the Dutch painter Hercules Seghers (1589/90–circa 1638), and Rembrandt also painted a few; these landscapes are among the most inventive and individual productions of both artists. It was, however, Philips Koninck, probably a student of Rembrandt, who developed the genre to its fullest form, making it his own specialization. The thick brushwork and strong contrasts between areas of light and shade in the Museum's painting—one of Koninck's masterpieces—are strongly reminiscent of Rembrandt. The naturalism evident in the treatment of the sky, however, is quite unlike the older artist's manner.

The aesthetic issues raised in a picture of this kind are extremely provocative. Few other artists dared to divide the canvas almost exactly in half with a single straight, unbroken horizon line. The problem of effectively combining the two halves is one that Koninck deliberately posed for himself, and its solution lends a drama to the subject that few landscapes possess.

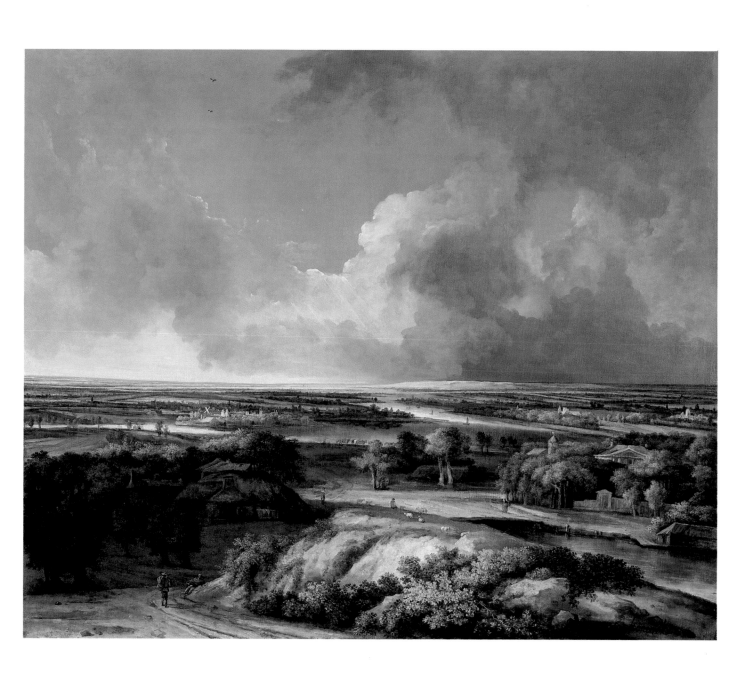

JAN VAN HUYSUM
Dutch, 1682–1749
Vase of Flowers, 1722
Oil on panel
79.5 x 61 cm (31¼ x 24 in.)
On ledge, signed *JAN VAN HUYSUM FECIT 1722*
82.PB.70

Perhaps more than any other artist, Jan van Huysum reflects the Dutch fascination with nature and its myriad details. He worked at a time when the Dutch republic was already past its so-called golden age and had acquired the sophisticated taste and love of embellishment that we associate with the Rococo period in France. Van Huysum's work reflects this change in taste while retaining a fidelity to subject matter that was part of an established Dutch tradition.

Van Huysum invariably included many different kinds of flowers in his pictures, often recently bred or newly acquired specimens brought to him by Amsterdam's avid flower collectors. Enormous sums of money were spent on flowers at the time, and the circle of connoisseurs surrounding van Huysum could well appreciate his ability to depict them so exactly. The details of his highly finished technique were a jealously guarded secret.

The composition of *Vase of Flowers* is relatively straightforward. The vase is centrally placed with no more background than a slanting ray of light, which sets off the bouquet. Another van Huysum painting in the Museum's collection, which depicts both flowers and fruit, is also dated 1722 and may be a companion piece. The second picture, however, is composed asymmetrically; fruit flows over the ledge upon which it has been placed, some of the grapes and the pomegranate are already bursting and overripe. Although these features may simply be intended to evoke a luxurious standard of living, they may also be meant to contrast with the unspoiled quality of *Vase of Flowers*.

JAN VAN HUYSUM. *Fruit Piece*, 1722. Oil on panel.
79.5 x 61 cm (31¼ x 24 in.). 82.PB.71.

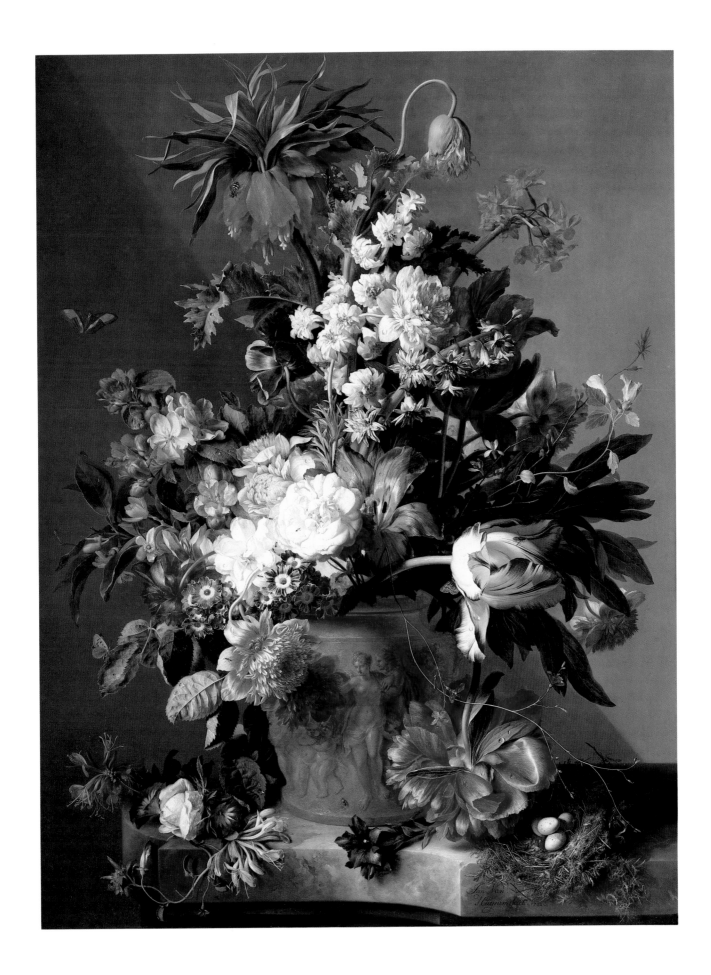

VALENTIN DE BOULOGNE
French, 1591–1632
Christ and the Adulteress, 1620
Oil on canvas
168 x 220 cm (66 x 86½ in.)
83.PA.259

The movement of Northern European artists to Italy was already a well-established tradition in the sixteenth century, and by the 1620s there were entire colonies of French and Dutch painters living there, primarily in Rome. With a few prominent exceptions, these artists especially admired the work of Caravaggio and his followers, whose pictures exemplified a "realist" movement in Italy. In the split that developed in Rome between the Caravaggesque "realists" and the so-called classicists, as typified by the Carracci and their followers (see nos. 11–13), many French artists aligned themselves with the Caravaggesque camp. They seem to have shared with their Italian "realist" counterparts a deep and personal religious sensibility as well as a taste for boisterous living.

Arriving in Italy in 1612, two years after Caravaggio's death, Valentin was among the first of the French expatriates to take up the Italian artist's style. He was still in his early twenties and remained in Rome until his own death in 1632, the result of having fallen into a fountain in a drunken stupor. Throughout his brief career he was one of the most faithful adherents to the Caravaggesque tradition.

The Museum's painting is quite characteristic of Valentin's approach. It is composed of half- or three-quarter-length figures whose strongly lit faces and hands contrast with the dark and undefined setting. Valentin did not employ much color, and the clothing lacks elaboration or bright pattern. He treated both religious and secular subjects in the same style and, as is apparent in the present composition, had a keen sense of drama, a trait common to most Caravaggesque painters.

This composition shows Christ preparing to write in the dirt on the ground (John 8:3–11); he stares at the adulteress being held by a group of male accusers of differing ages and types. All of them concentrate on Christ's action, and the emotion of the scene is conveyed by the variety of expressions their faces register and by the directness with which the episode has been composed.

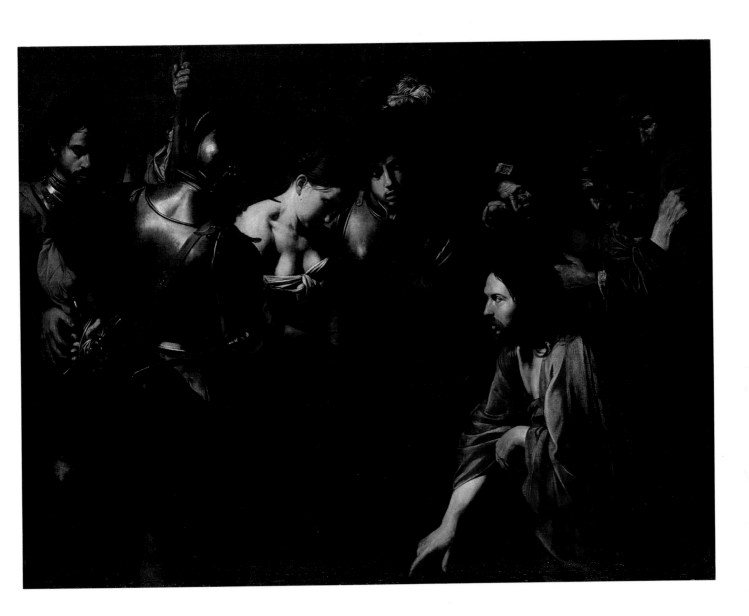

GEORGES DE LA TOUR
French, 1593–1652
The Beggars' Brawl, circa 1625–1630
Oil on canvas
84 x 138.5 cm (33 x 54½ in.)
72.PA.28

The subject of *The Beggars' Brawl* is the fight of two elderly itinerant musicians over a place to play their instruments. The man on the left, who wears a hurdy-gurdy slung around his shoulders, is defending himself with a knife and the crank of his instrument. He is menaced by another man who seems to be hitting him with a shawm, a kind of oboe, and who wears a second similar instrument at his waist. In his upraised hand the second beggar holds a lemon and squeezes its juice into his opponent's eyes. This is done either to test whether the man with the hurdy-gurdy is truly blind or simply to further agitate him. On the left an old woman seems to implore someone to help. At the right two more itinerants, one with a violin and the other with a bagpipe, enjoy the fight.

The subject is a rare one; many seventeenth-century artists painted peasants or musicians, but depictions of quarrels among them are hardly ever found. One of the few examples is a print by the French artist Jacques Bellange that may have supplied the inspiration for the Museum's painting. La Tour used motifs from Bellange's prints on other occasions and obviously admired him.

La Tour spent his life in Lorraine in eastern France and is not known to have ventured far from there. His style therefore is based upon whatever works he might have seen in or near the relatively small city of Lunéville where he lived, and it is not surprising that prints should have been a major source of his inspiration. The violinist on the right in the Museum's painting may in fact be derived from a print by the Dutch artist Hendrick ter Brugghen (see no. 20), which depicts a grinning man in a striped coat holding a violin and wearing a feathered cap. The print probably dates from the mid- to late 1620s, as does La Tour's painting.

In a more general way La Tour's work belongs to the realist tradition that swept Europe in the aftermath of the very revolutionary pictures painted by Caravaggio in Italy (see no. 30). It is doubtful that La Tour ever saw any original paintings by Caravaggio, but the desire for a renewal of naturalism in painting was so strong that it quickly found adherents everywhere.

LAURENT DE LA HIRE
French, 1606–1656
Glaucus and Scylla, circa 1644
Oil on canvas
146 x 118 cm (57½ x 46½ in.)
84.PA.13

While most of the greatest seventeenth-century French artists went to Rome to work—Poussin (see no. 33) and Claude Lorrain spent most of their lives there—others never left France. Although strongly influenced by Italian style, both Laurent de La Hire and Georges de La Tour (see no. 31) never visited Italy.

La Hire's work combined the classicism of Poussin with Claude's sensitivity to landscape. In his own time, La Hire was considered to be of nearly comparable importance to those painters, but perhaps partly because he did not leave his native country, his impact on the history of art has been less profound.

La Hire painted both mythological and religious scenes, usually including some landscape elements and often classical ruins. He had a particularly acute sense of color, sometimes employing vivid hues but at other times focusing on the nuances of pastel shades. *Glaucus and Scylla* includes less landscape than is usual for the artist, but the soft pinks and blues of the water and sky provide a beautiful counterpoint to the tender greens of the reeds and foliage.

The figure of Glaucus, probably one of the most remarkable La Hire ever painted, is especially striking. The bearded sea god raises himself out of the water and, touched by the beauty of Scylla on the rocky ledge above, draws his beard aside to reveal Cupid's arrow protruding from his chest. The rolling curls of Glaucus' beard are rendered with exceptionally fine modeling, and his scaly tail unwinds eellike among the reeds. The total effect is much more decorative, and perhaps less erudite, than the works of Poussin or Claude, but it is nonetheless indicative of a very high degree of technical skill.

The Museum's painting was one of a group that served as cartoons for a set of six tapestries woven at the Paris manufactory later known as Gobelins. Two of the other paintings in the series bear the date 1644, and all of them may have been executed at approximately the same time. Thematically, the entire series was dedicated to the loves of the gods, precisely the kind of decorative subject that proved most popular for tapestries and paintings not only during the seventeenth century but also during the eighteenth, the golden age of French decorative art.

NICOLAS POUSSIN
French, 1594–1665
The Holy Family, 1651
Oil on canvas
96.5 x 133 cm (38 x 52⅜ in.)
81.PA.43 owned jointly with the Norton Simon Museum

Of the many foreign artists who worked in Rome, Poussin was probably the most famous. Even in his own time, he was revered as a master. Like Valentin before him (see no. 30), Poussin spent nearly his entire adult life in the papal city. The contemporary Italian biographer Bellori wrote: "France was his loving mother, and Italy his teacher and second fatherland." The artist drew inspiration from his Roman surroundings and became the fountainhead of the classical tradition in seventeenth-century Italy, profoundly influencing the art not just of his adopted land but of all Europe.

Later in life, Poussin painted a large number of religious themes, in particular several depicting the Holy Family. The Museum's painting, probably the most beautiful and ambitious of these works, includes Christ and his immediate family as well as the infant John and his mother, Elizabeth. The action focuses on the embrace of John and Jesus; the ewer, towel, and basin of water held by the group of putti (infant boys) at the right may refer to the bathing of the child or to John's later baptism of Christ.

The painting is composed in a highly classicizing vein and exemplifies Poussin's very rationalistic inclination. He often placed figures in a setting so meticulously composed that it seems to have a geometric underpinning. In contrast to the "realism" of the Caravaggesque painters (see no. 30), whose popularity had faded by this time, Poussin normally used fairly strong color and placed his subjects in idyllic settings bathed in bright light. The figures hark back to those of Raphael (1483–1520), the model for most classicizing artists of later centuries, and the landscape derives from the Venetian tradition of Giorgione (circa 1476–1510) and Titian (circa 1487–1576).

The Museum's painting was commissioned in 1651 by Charles III de Blanchefort, duc de Créqui, one of the many wealthy patrons who competed for Poussin's pictures. The duke's grandfather was the French ambassador to Rome under Louis XIII, the first Frenchman to have bought a work from Poussin and an important figure in spreading the artist's reputation in France. Continuing the tradition, the duc de Créqui, who was himself to be appointed ambassador to Rome under Louis XIV, became one of Poussin's most important collectors.

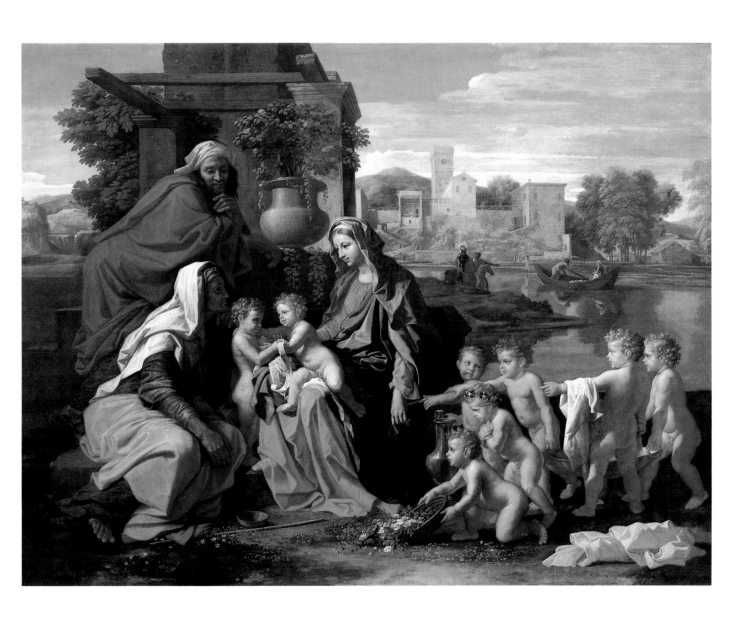

JEAN-FRANÇOIS DE TROY
French, 1679–1752
Before the Ball (La Toilette pour le Bal), circa 1735
Oil on canvas
81.8 x 65 cm (32 3/8 x 25 9/16 in.)
At bottom right, signed *De Troy 1735*
84.PA.668

De Troy was one of eighteenth-century France's most versatile artists. The son of a well-known portrait painter, he came to excel not only in that field but also in the painting of historical, mythological, and religious subjects. In addition, he designed tapestries and decorations for the royal residences at Versailles and Fontainebleau. He worked successfully in both large and small scale, and his works, like those of Watteau (1684–1721), vividly convey the elegance and sophistication characteristic of fashionable Parisian society of the time.

The Museum's painting, along with its companion piece, *Le Retour du Bal* (*The Return from the Ball*; now lost, but known from an engraving), was painted around 1735 for Germain-Louis de Chauvelin, the minister of foreign affairs and keeper of the seal under Louis XV. Evidently, Chauvelin was dismissed from his post before the paintings could be delivered. De Troy therefore retained possession and exhibited them in the Salon of 1737. At the time, the pair were declared to be the artist's finest works.

Before the Ball typifies de Troy's *tableaux de mode*, depictions of the aristocratic class at home and at leisure. These paintings are now considered to be among the most significant of the artist's works. In the Museum's painting a group of men and women watch a maid put the final touches on her mistress' hair. The onlookers are already wrapped in cloaks and hold masks in eager anticipation of the evening's festivities. The richly appointed room is decorated with wall brackets and furniture in the current style. The now-lost companion piece presented the same group removing their capes and masks upon their return from the ball.

At the time, some critics disapproved of the life-style celebrated by such paintings, but de Troy apparently moved easily in fashionable circles and does not appear to have been moralizing about the vanity of aristocratic behavior. On the contrary, he seems to have relished it and to have well understood its nuances and conventions. He has succeeded in capturing the slightly charged and even erotic climate of the proceedings, and there is a certain realism in his observation that betokens a clear and acutely perceptive eye.

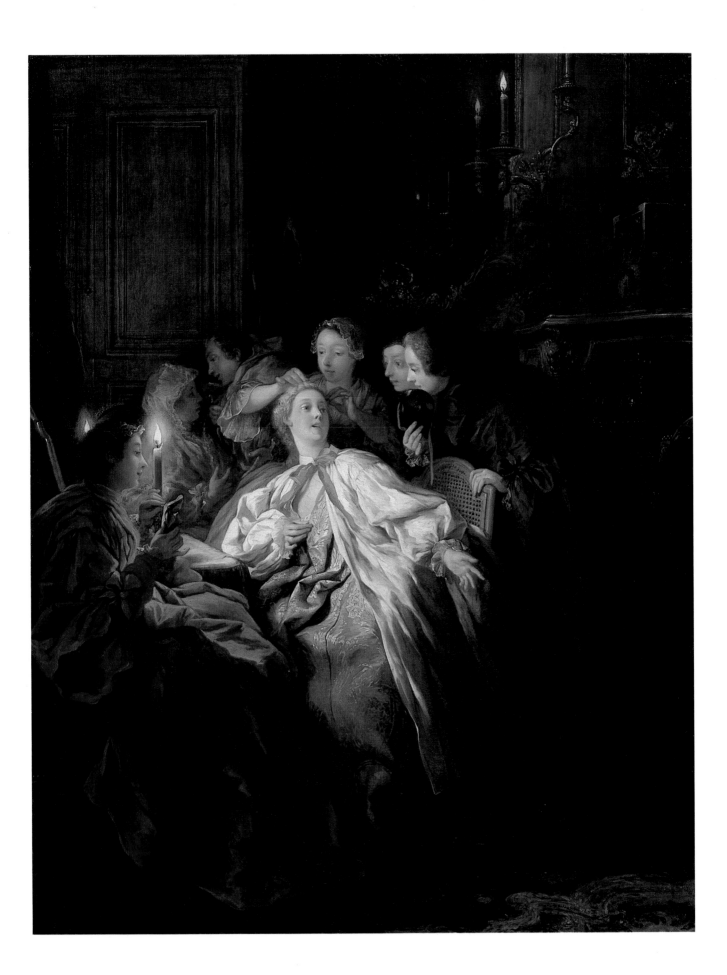

JEAN-BAPTISTE GREUZE
French, 1725–1805
The Laundress (La Blanchisseuse), 1761
Oil on canvas
40.6 x 31.7 cm (16 x 12⅞ in.)
83.PA.387

During the last half of the eighteenth century, Greuze was the most famous and successful exponent of genre painting in France. He normally chose themes with strong moralistic overtones, the closest parallels to which were to be found in the contemporary theater rather than in the work of his fellow artists. At a time when the academies extolled the depiction of historical themes as the highest form of painting, Greuze attempted to raise his more mundane subject matter to a comparable level of importance.

Like other French artists before him, Greuze was inspired by the study of the seventeenth-century Dutch and Flemish pictures that were extensively collected and admired in France during the eighteenth century. Many of his subjects are in fact taken directly from the works of Dutch and Flemish artists, who were the first to concentrate on depictions of working people and servants. In the 1730s the French artist Chardin had painted a similar laundress, and Greuze was no doubt familiar with his picture. Chardin emphasized the humility and quiet dignity of his subject, but Greuze chose to give his laundress a provocative glance and to stress her disheveled appearance. By exposing her ankle and foot, the artist imparted a suggestion of licentiousness to the young woman. Through further details of her clothing and the disorderly setting—details that would have been much more readily interpreted by his contemporaries than by modern viewers—he further attempted to warn against the girl's tempting glance.

The Laundress was exhibited in the Salon of 1761, the year Greuze first achieved success, and the critic Denis Diderot, one of the artist's first prominent admirers, described the girl in the painting as "charming, but…a rascal I wouldn't trust an inch." Soon after its first exhibition, the Museum's painting was acquired by the collector Ange Laurent de La Live de Jully, the artist's most important patron during this period.

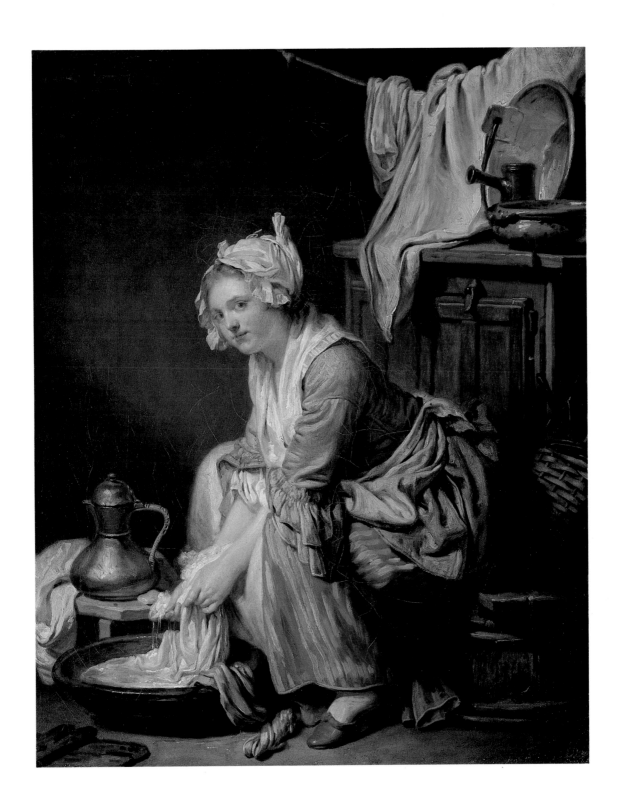

THEODORE GERICAULT
French, 1791–1824
Portrait Study, circa 1818–1819
Oil on canvas
46.5 x 38 cm (18¼ x 15 in.)
85.PA.407

Portraits played a relatively small part in Gericault's career, and he is best known as a painter of heroic or historical subjects. The present picture, however, clearly demonstrates that he was capable of capturing a sitter's character with great sympathy and spontaneity. The portrait is obviously the study of a model, not a commissioned work, and Gericault probably chose this subject for his extraordinary face.

The artist is known to have sympathized with the cause of abolitionism and often included black figures in his pictures, sometimes in heroic roles. His portrayal of black subjects was influenced in part by stories of the wars the French army had fought with black insurgents in Haiti during the first years of the century. He must also have known blacks from North Africa and shared the fascination with exotic cultures that characterized many nineteenth-century French artists. Gericault and many of his contemporaries saw the black man in a romantic light, attributing to him an unspoiled nobility that more "civilized" Europeans could not attain. The same "primitive" innocence was frequently attributed to the American Indian.

It is generally thought that the sitter in the Museum's portrait was a certain Joseph— his family name is not recorded—who came from Santo Domingo in the Caribbean and worked initially in France as an acrobat and then as a model. He acquired some fame in Paris because of his considerable physical beauty, wide shoulders, and slender torso. Gericault used Joseph for a great many studies, mostly drawings, and as the principal figure in his most famous work, *The Raft of the Medusa* (1819; Musée du Louvre, Paris). The sitter in the Museum's painting looks a bit old to have been used for such a dramatic pose, however, and therefore may not be the same model. The many studies of Joseph that are most obviously related to the finished *Raft of the Medusa* do not include the mustache and slightly sad features of the Museum's portrait. Nevertheless, the latter is assumed to belong to the period of 1818 to 1819 when Gericault was most preoccupied with *The Raft of the Medusa,* which ultimately included three black figures.

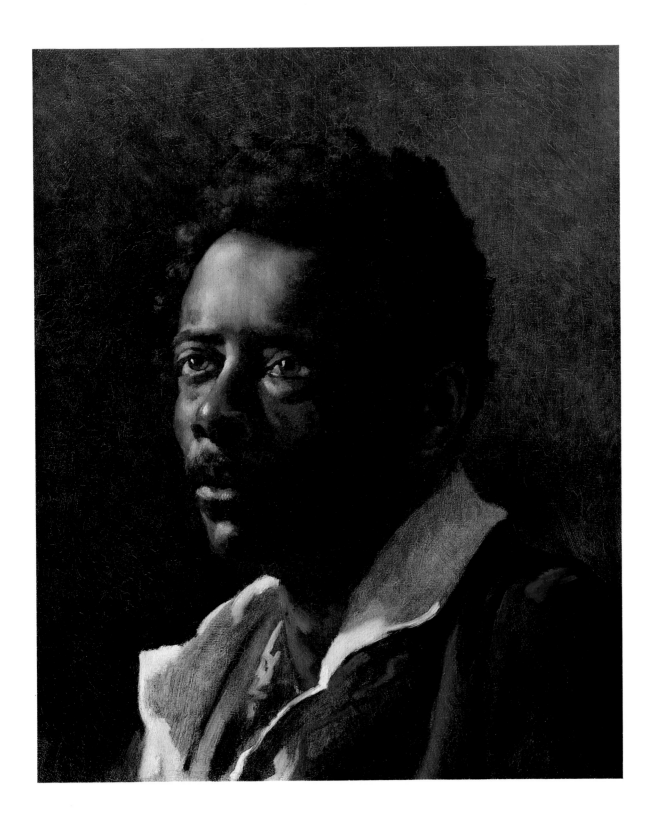

JACQUES-LOUIS DAVID
French, 1748–1825
Portrait of the Sisters Zénaïde and Charlotte Bonaparte, 1821
Oil on canvas
129.5 x 100 cm (51 x 39⅜ in.)
At bottom right, signed *L. DAVID. / BRVX. 1821*
86.PA.740

David was the artist closest to the Napoleonic government from its inception, and he was commissioned to paint its most important events. His enthusiastic espousal of an art based on antique models was matched by Napoleon's desire to emulate Greco-Roman civilization and principles. Both men played essential roles in the development of Neoclassicism, and the style thus created dominated Europe for nearly a half-century after the fall of the Napoleonic Empire. By the time the Museum's picture was painted, however, the French monarchy had been reestablished. Although David could have returned to France, he had decided to remain in exile and was living in Brussels.

The sitters of this double portrait are the daughters of Napoleon's older brother, Joseph Bonaparte (1768–1844). A key figure of the Napoleonic era, Joseph was made king of Naples and Spain at the height of France's aggressive expansion. After Napoleon's final abdication in 1815, Joseph went into exile in the United States, settling near Philadelphia in Bordentown, New Jersey. His family remained in Europe, however, and for a time resided in Brussels.

On the left of the painting is nineteen-year-old Charlotte, dressed in gray-blue silk. She wished to become an artist and received drawing lessons from David, with whom she maintained a friendly relationship. On the right, dressed in deep blue velvet, is Zénaïde Julie, age twenty, who later became a writer and translator of Schiller, the German poet and dramatist. The sisters are depicted wearing tiaras and seated on a couch decorated with bees, the Bonaparte family emblem. As they embrace, Zénaïde holds out a letter from their father on which a few words can be deciphered as well as the information that it was sent from Philadelphia.

The portrait exhibits some of the trappings of imperial fashion, notably the couch in the Roman manner and the high waistlines of the gowns; yet it is no longer as severe and solemn as many of the artist's earlier works, and there is a sense of warmth and informality that perhaps signals a lessening of David's earlier idealistic fervor. The fabrics are rendered with great sensitivity, and the portrait, no doubt commissioned by the exiled Joseph Bonaparte, conveys a sympathetic charm that apparently survived in the face of the family's unhappy circumstances.

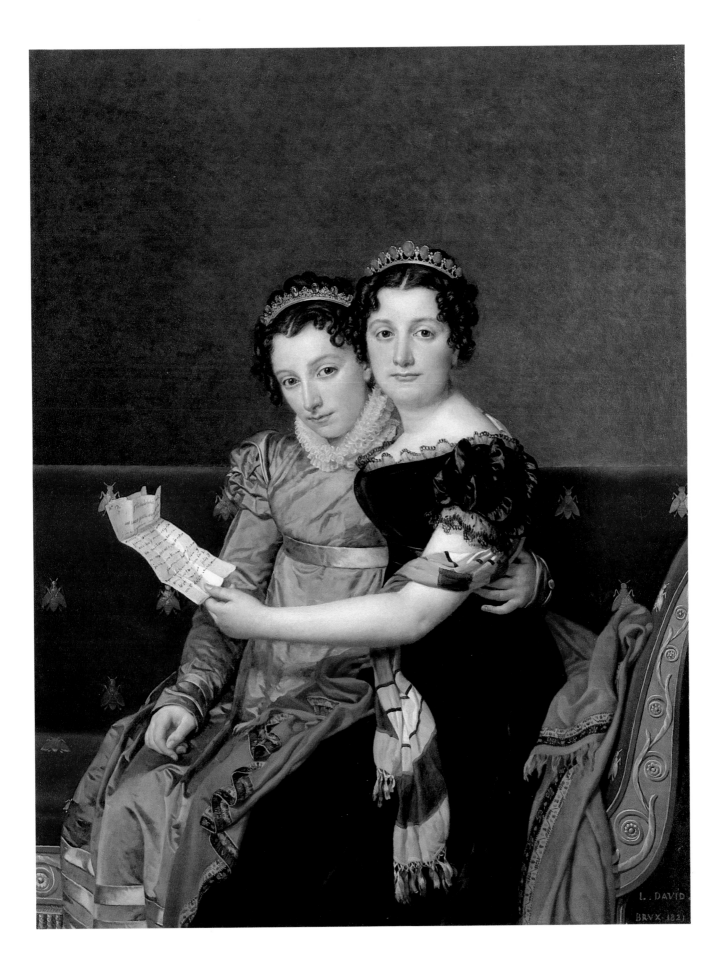

GUSTAVE COURBET
French, 1819–1877
Bouquet of Flowers, 1862
Oil on canvas
100.5 x 73 cm (39½ x 28¾ in.)
At bottom right, signed *Gustave Courbet ,62*
85.PA.168

In mid-nineteenth-century France, a movement advocating greater realism sprang up in opposition to traditional Academic painting, which had stressed idealism and the need to embellish upon nature. Movements advocating increased fidelity to nature had occurred in various countries throughout the history of art, but this one, led by Gustave Courbet, drastically altered the course of art history during the remainder of the nineteenth century and into the twentieth.

Courbet resolved to paint only that which he could see with his own eyes, while striving at the same time to capture the spiritual essence of his subjects. A confirmed socialist, his pictures often incorporated political and social commentary, and his figure compositions were invariably controversial. The majority of Courbet's work, however, was in landscape, and he spent a great deal of time in the countryside. He often included animals in his paintings, and for a brief period he concentrated on flowers.

In a sense, flower pieces were above controversy. They allowed the artist to work directly from nature with an infinite variety of color if he so wished. Courbet's preoccupation with floral subjects coincided with a relatively tranquil period in his career. For eleven months during 1862/63, he stayed at the Château de Rochemont near Saintes at the invitation of his wealthy friend Etienne Baudry. During this time, he painted more than twenty floral pieces. The present example, which he sold to a local banker, is the largest and most impressive of this group. It superficially resembles Dutch flower pieces, such as those by van Huysum (see no. 29), but is much more spontaneous and reflects the enormous vitality with which Courbet imbued all his subjects. He did not labor over details but described nature in its most elemental terms, using it as a vehicle for a less restricted technique and composition.

Flower pieces had not been considered worthy subjects for serious painters working within the criteria established by the Académie des Beaux-Arts, but as the century progressed, they became more common. The Impressionists, who concentrated on landscape, revived the practice, though on a limited basis (see no. 40), and the present work anticipates similar pictures by Renoir painted not long afterward.

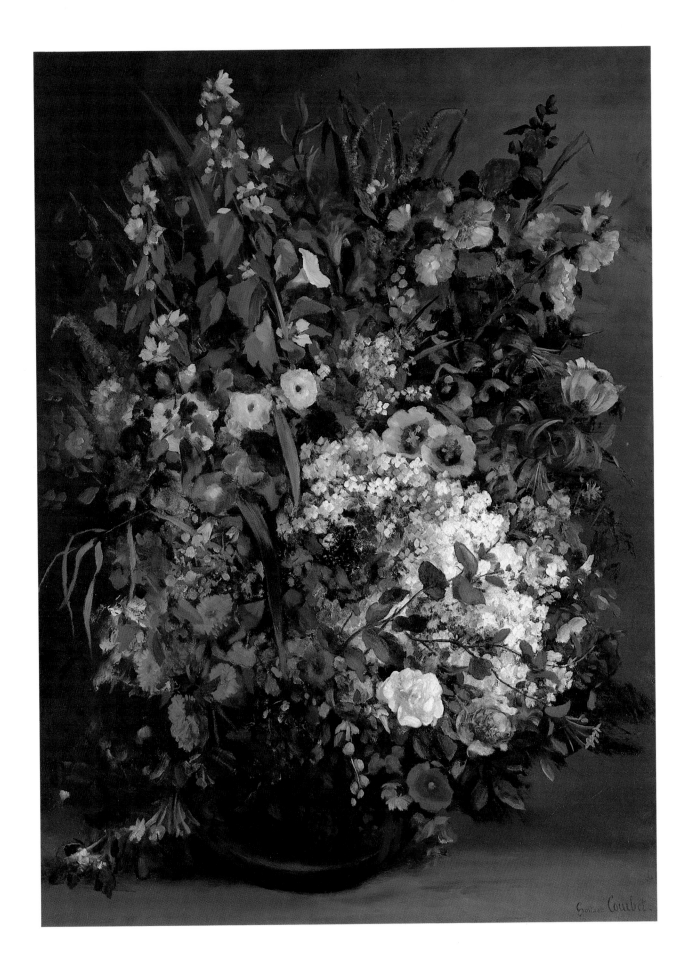

JEAN-FRANÇOIS MILLET
French, 1814–1875
Man with a Hoe, 1860–1862
Oil on canvas
80 x 99 cm (31½ x 39 in.)
At bottom right, signed *J. F. MILLET*
85.PA.114

The French revolutions of 1830 and 1848 gave rise to numerous liberal movements intent upon correcting social ills, and a widespread belief existed among reformers that painting should reflect these concerns rather than portray figures with classical associations. Although Millet was not a social reformer, his personal convictions caused him to align himself with the reformers.

A religious fatalist, Millet believed that man was condemned to bear his burdens with little hope of improvement. He wanted to show the nobility of work in his art, and to this end, he concentrated his attention on peasants and farm laborers. The Industrial Revolution had caused a steady depopulation of farms, and a painting such as *Man with a Hoe* was meant to show the farmer's perseverance in the face of unrelieved drudgery. In the distance a productive field is being worked, but the back-breaking task of turning the rocky, thistle-ridden earth must precede this.

Millet's painting was criticized for the especially brutish image of the peasant. Of all the laborers depicted by Millet, this farmer is the most wretched. He has been brutalized by his work, and his image understandably frightened the Parisian bourgeoisie. Millet may have been making a reference to Christ's Passion because at the time the thistles were widely interpreted as referring to the crown of thorns. The face of the peasant, however, did not fit the then-popular conception of Christ. *Man with a Hoe*, in any event, was considered a symbol of the laboring class for many decades and in 1899 was immortalized by the socialist poet Edwin Markham in a poem of the same name in which he rhetorically asked, "Whose breath blew out the light within this brain?"

During and after its public exhibition in the Salon of 1863, *Man with a Hoe* was attacked by critics for its supposed radicalism, and Millet was forced to declare that he was not a socialist or an agitator. Although his attitude pleased neither reformers nor the establishment, his paintings proved to be very popular, particularly in the United States. *Man with a Hoe*, one of his most famous pictures, had been purchased by a San Francisco collector by the turn of the century.

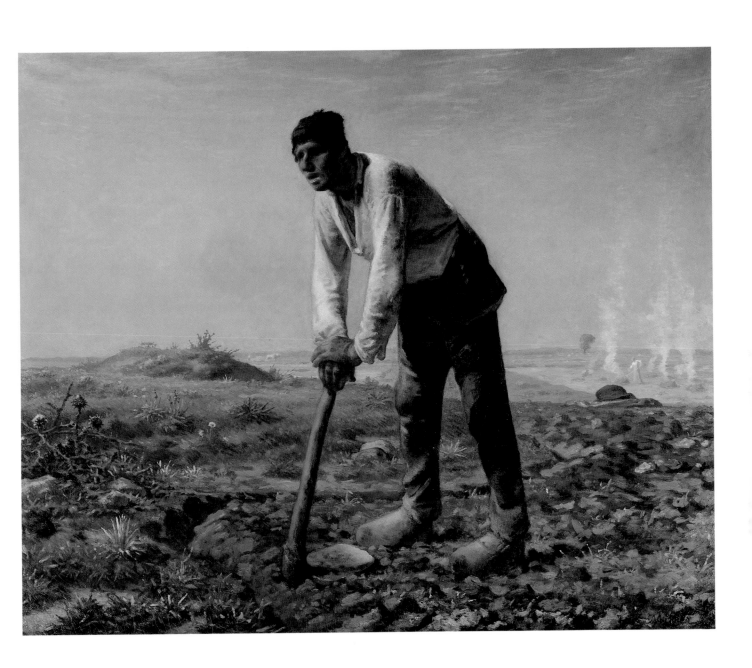

CLAUDE MONET
French, 1840–1926
Still Life with Flowers and Fruit, 1869
Oil on canvas
100 x 80.7 cm (39 3/8 x 31 3/4 in.)
At top right, signed *Claude Monet*
83.PA.215

The Impressionist movement was concerned above all with atmosphere and light and their effects on the perception of color and form. Its members in general eschewed the social themes often taken up by Courbet (see no. 38) and other French artists working around the middle of the nineteenth century (see no. 39). Thus, although Monet and Courbet knew and admired each other's work, they were clearly products of different generations. Monet's style may have excited controversy, but his subject matter did not.

The Museum's *Still Life with Flowers and Fruit* was created in 1869 in the town of Bougival just outside Paris. Monet spent the summer and autumn of the year in that lovely resort town, which was famous for the crowds of artists it attracted. While there, he was in regular contact with Pissarro (see no. 41) and Renoir. Monet and Renoir often painted in each other's company and created a series of pictures of the same subjects. Their famous views of La Grenouillère, a popular restaurant on the Seine with swimming facilities, were painted at this time.

Renoir also depicted the arrangement of flowers and fruit seen in the Museum's painting. The two artists probably worked side by side, perhaps in Monet's studio. Renoir's painting (now in the Museum of Fine Arts, Boston) is somewhat smaller and less complex than Monet's. Carefully structured and composed, Monet's picture leaves a certain amount of empty space, which suggests the depth of the scene. The light is subdued, but the color is not, making this one of his strongest still lifes. The paint is applied in thick strokes, and the surface reflects a significant amount of reworking, an indication that the artist devoted more than the usual amount of time to its resolution.

The principles of Impressionism were best demonstrated in paintings of the fields, rivers, and towns of the region immediately surrounding Paris, and members of the movement were comparatively uneasy working indoors. As a consequence, Monet and his fellow Impressionists painted relatively few still lifes. Artists such as Cézanne (see nos. 42, 43) and Gauguin (see no. 45) would come to treat this subject matter seriously just a short time later, however, and Monet's work in this field would influence the evolution of their painting.

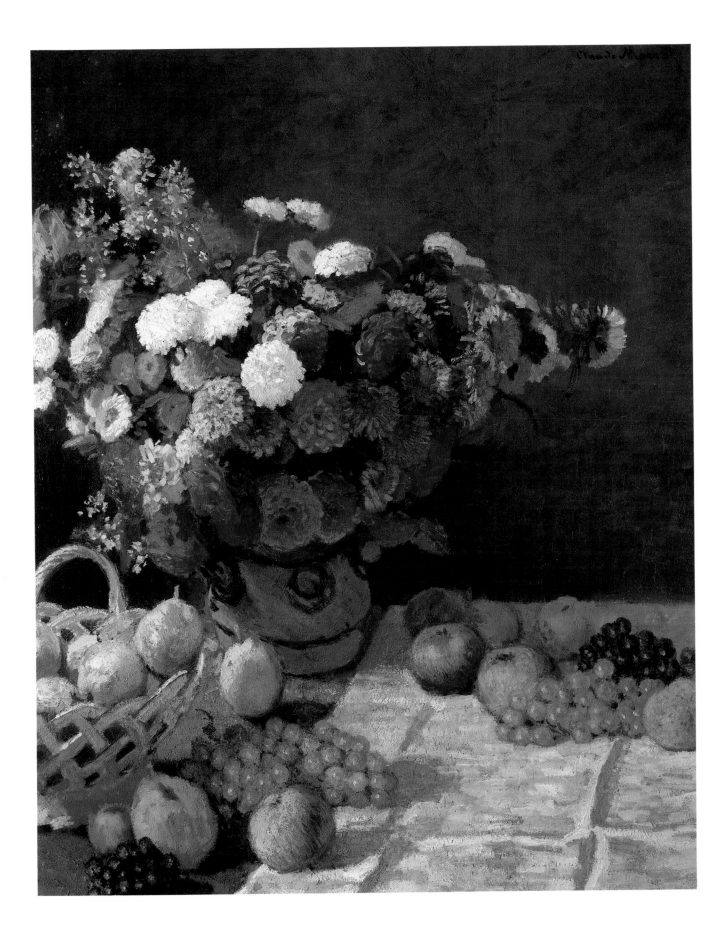

CAMILLE PISSARRO
French, 1831–1903
Landscape near Louveciennes (Autumn), 1870
Oil on canvas
89 x 116 cm (35 x 45⅝ in.)
At bottom right, signed *C. Pissarro / 1870*
82.PA.73

Pissarro moved to the town of Louveciennes in late 1868 or early 1869, a time when his friends Renoir and Monet were working in nearby Bougival (see no. 40). These two peaceful villages on the Seine just west of Paris have since come to be jointly known as the cradle of Impressionism.

Pissarro had a somewhat more traditional view of landscape painting than the other Impressionists and retained a more conventional spatial and geometric structure in his compositions. Under the influence of Monet, however, his style gradually relaxed and became freer; the present painting is a particularly good example of this transition. It is in fact one of the most "Impressionistic" works the artist ever created. By placing the road in the foreground parallel to the painting's edge and breaking up the surface with trees and a pattern of foliage, he denied himself the usual spatial reference points. The vegetable gardens along the side of the road have become daubs of color, and the brushwork throughout is relatively unrestrained.

The artist chose as his site a small village path fronted with modest rural homes. The few figures in the painting are local residents, and in spite of their rather summary depiction, they could not be mistaken for the Parisians who frequently flocked to Louveciennes for a pleasant weekend. Pissarro lived in a house just a short walk down this same path. Not far away was the Seine and the swimming place near La Grenouillère, the restaurant made famous by Renoir and Monet. Pissarro was more of a pure landscapist than either of these artists and was inclined to avoid crowds. He also used a more restricted palette than his companions, concentrating on variations of green and brown to render what he saw. Unlike the other Impressionists, who experimented with color and tended to purify it whenever they could, Pissarro's colors reveal his more "realistic" outlook and a disinclination to embellish upon what was actually before him. In addition to being one of Pissarro's more adventurous canvases, *Landscape near Louveciennes* is one of the largest he ever executed.

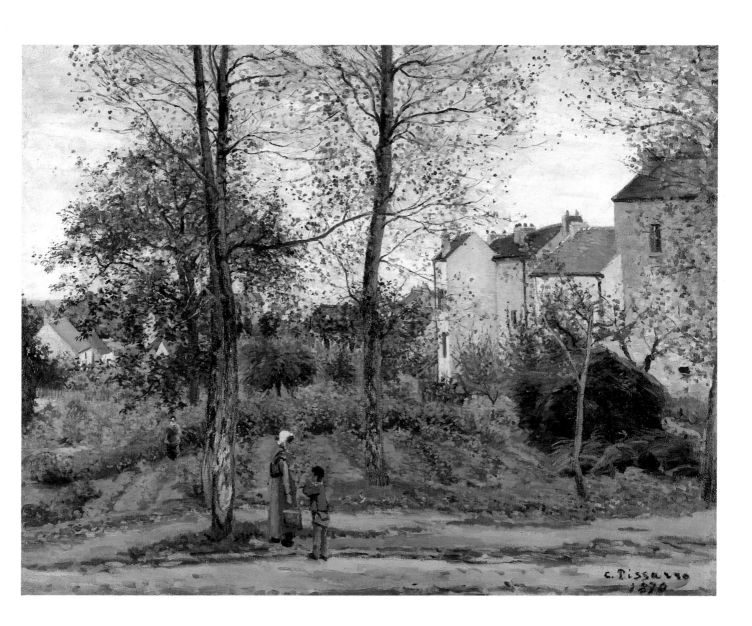

PAUL CEZANNE
French, 1839–1906
Portrait of Antony Valabrègue, circa 1869–1871
Oil on canvas
60 x 50 cm (23⅝ x 19¾ in.)
85.PA.45

Cézanne did not achieve any measure of public acceptance until the mid-1870s, when he and members of the Impressionist circle—which included Pissarro, Monet, Degas, and Renoir—inaugurated their own exhibitions in Paris. Prior to that time, their work was regularly refused at the annual Salons, and Cézanne's pictures in particular were singled out for scathing criticism. His painting technique was very direct and at times even violent. Although in general it dismayed critics, it inspired admiration from a few like-minded artists; certain writers, especially Cézanne's long-time friend Emile Zola; and even a few art historians, among them the sitter of the present portrait, Antony Valabrègue (1844–1900).

Like Cézanne, Valabrègue was born in Aix-en-Provence in southern France. Throughout the 1860s the two men spent a great deal of time in each other's company and, with Zola, exchanged ideas, poetry, and numerous letters. In spite of this friendship, Valabrègue, who was a critic, journalist, and poet, never wrote anything about Cézanne or his work.

In 1866 Cézanne painted a large portrait of Valabrègue which was rejected by the Salon. It was painted not with brushes but with a palette knife, an instrument the artist favored during this period and that contributed to the harsh, rough appearance of his work. Subsequently, he painted several other portraits of his friend, including the present example, thought to have been executed around 1870.

Valabrègue was apparently a shy and fastidious man, fairly tall and slender in build. The present portrait conveys these characteristics and reveals the artist's increasingly secure sense of form and painterly structure. By this time he had begun using brushes more regularly, and his coloring had become lighter and more optimistic. He also had begun to demonstrate a more reflective and analytical stance toward his work that would ultimately lead him to turn increasingly to landscapes and still lifes (see no. 43). The Museum's portrait shows Cézanne midway in this transition, boldly rendering his friend in thick strokes of color but already restraining his own impetuous side in favor of a more serious examination of form.

PAUL CEZANNE
French, 1839–1906
Auvers, Seen from the Village of Val Harmé (Auvers, du Côté du Val Harmé), 1882
Oil on canvas
73 x 92 cm (28¾ x 36¼ in.)
85.PA.513

It was largely through Pissarro's influence (see no. 41) that Cézanne abandoned his Neo-Romantic figure paintings (see no. 42) in favor of analytical landscapes and still lifes. In 1872 Pissarro settled in Pontoise, northwest of Paris; Cézanne moved there to join him later in the same year. Shortly after, Cézanne moved on to Auvers, a small town nearby where Dr. Paul Gachet, who was a friend of Pissarro and an early patron of both artists, also lived. Cézanne remained in the neighborhood for about two years—returning later for shorter stays—so that he might work with Pissarro, whom he admired and relied upon for both moral and financial support.

Pissarro, who was nine years older than Cézanne, persuaded the younger artist to paint from nature and to take his inspiration from sources other than his own highly charged imagination. As a result, his sense of color changed radically, and he began to work in subtler variations of muted primary colors, foregoing the darker and more dramatic range of his earlier pictures. He briefly painted in a manner that allied him with the Impressionists and was included in their first major exhibition of 1874. Gradually, however, he developed a preoccupation with landscape painting that led to the steadily more complex and analytic compositions of his maturity.

The date of the present picture has been established at 1882 based upon its similarity to a view of the same town by Pissarro which bears that date. By this time Cézanne had left the Impressionist fold, but he still maintained his attachment to Pissarro. The implication is that both men stood at virtually the same point on a hill; Pissarro rendered the scene in cheerful dabs of color while Cézanne interpreted it as a complicated construction composed of parallel strokes in greens, grays, and browns. Cézanne attempted to analyze and depict an underlying structure, thereby deemphasizing the picturesque detail of leaves, grass, and sky. The view is painted fairly rapidly, with very few changes, and in some places, such as the foreground, the artist has permitted much of the unpainted canvas to show through between the brushstrokes. This trait characterizes much of his mature work and is a sign of his newly won confidence.

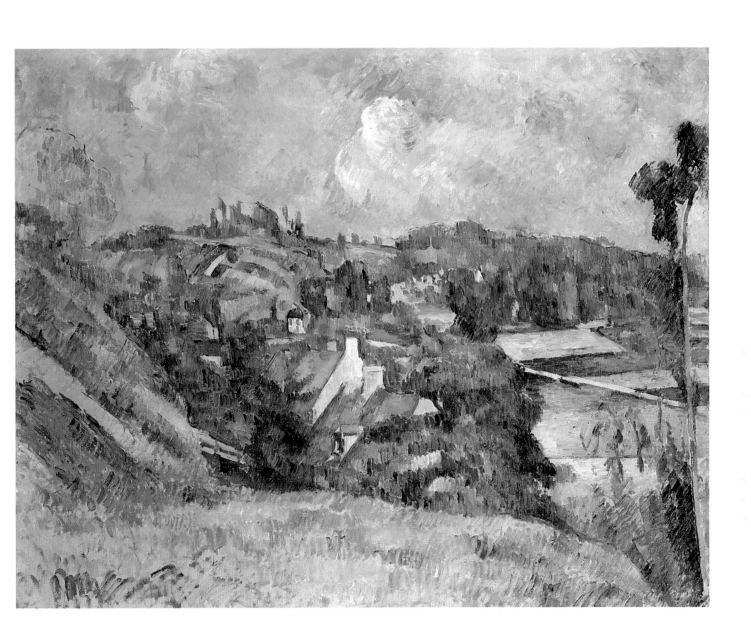

EDGAR DEGAS
French, 1834–1917
Waiting: Dancer and Woman with Umbrella on a Bench (L'Attente), circa 1882
Pastel on paper
48.2 x 61 cm (19 x 24 in.)
At top left, signed *Degas*
83.GG.219 owned jointly with the Norton Simon Museum

Degas, like many French artists at the middle of the nineteenth century, concentrated on representing the various facets of Parisian daily life. He treated both mundane and fashionable subjects ranging from women washing and ironing to the occupations of musicians and jockeys. The single most common theme in Degas' long career, however, was the ballet. Hundreds of his paintings and drawings depict many aspects of the dancer's art. He is credited with once remarking that the dance was only "a pretext for painting pretty costumes and representing movements," but his work belies this somewhat flippant observation. Degas knew many of his dancers very well and never portrayed their male counterparts. This would suggest that they were more to him than simply a vehicle for the treatment of color or composition.

Although the ballets that were regularly performed at the Opéra in Paris were rarely classical, Degas depicted his dancers wearing traditional costumes or rehearsal garments. Conservative by nature, he was appreciative of older customs. Just as his paintings often harken back to Renaissance examples for their inspiration, so the classical ballet signified for him the art of ancient Greece. The American collector Louisine Havemeyer—who formerly owned the Museum's picture—is supposed to have inquired of the artist why he painted so many dancers; he replied that ballet was "all that is left us of the combined movements of the Greeks." Somewhat paradoxically, however, he most often showed his dancers at practice or in repose and seldom painted actual performances.

The Museum's pastel, which is thought to have been executed about 1882, includes a dancer and an older woman dressed in black, holding an umbrella. Tradition has it that the subject was a young dancer from the provinces who was waiting with her mother for an audition. Degas sometimes included instructors or musicians in his works to act as foils to the more colorful dancers; placing the rather severe figure of the older woman next to a young dancer rubbing her sore ankle is a variation of this practice. It also emphasizes the discrepancy between the glamour and artifice of the stage and the drabness of everyday life. Degas' continued preoccupation with the colorful and graceful, however, separates him from the realist tradition of Courbet (see no. 38) and Manet.

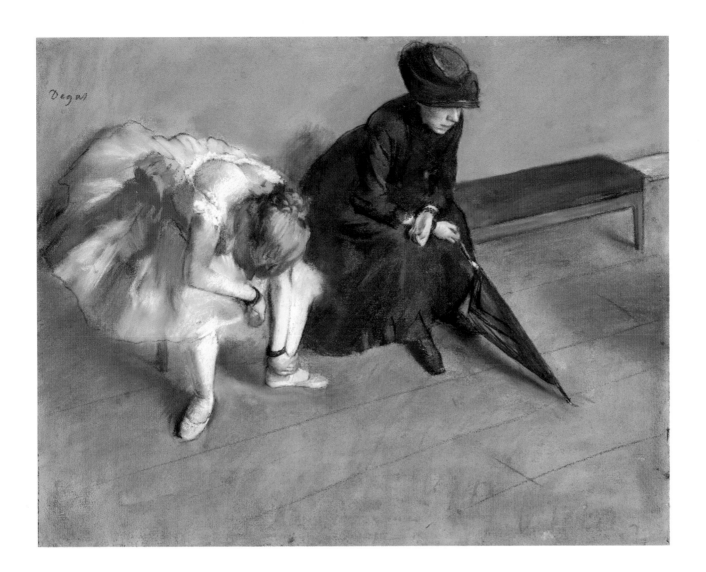

PAUL GAUGUIN
French, 1848–1903
Breton Boy with a Goose, 1889
Oil on canvas
92 x 73 cm (36¼ x 28¾ in.)
At lower left, signed *P. Gauguin 89*
83.PA.14

Throughout his life Gauguin sought a retreat from the corrupting influences of civilization, a place free from modern conventions and the complications of urban existence. This quest eventually led to his well-known move to Tahiti, but from 1886 to 1890, the four years before this self-imposed exile, he settled in Brittany and lived on and off in two villages, Pont-Aven and Le Pouldu. He attracted a number of followers and admirers, establishing a colony of artists, all of whom were heavily influenced by his style and personality. The work of this group was characterized by a love of "primitive" or traditional cultures, both European and non-European; a strong religious instinct; and complex theories concerning the use of color. These same preoccupations distinguished art movements in other countries at the time, but Gauguin, by virtue of his work and his life, has preeminently come to embody these concerns.

The Museum's painting was created in the autumn of 1889 at Le Pouldu. It depicts a Breton boy with a switch tending a large white goose. He leans on a rock before a group of trees, beyond which appears a town. The rough and desolate character of Brittany's landscape appealed to Gauguin, and he has conveyed a certain bleakness and melancholy, despite the use of vivid colors—bright yellow-greens, ochers, and reds.

Although Gauguin began his career in the thrall of the Impressionists, he had by this time withdrawn from the movement, and his art often contains elements of the style known as Art Nouveau. This may be seen in the increasingly flattened and simplified rendering of natural forms, which imparts an almost decorative quality to his painting. Trees, for example, become nearly geometric shapes, and an object such as the red fish-shaped bush on the left of the Museum's painting appears almost airborne, floating upon the bright green expanse of grass behind. One senses here that the artist was struggling to locate new compositional solutions and was more concerned with experimentation than with resolving each individual detail.

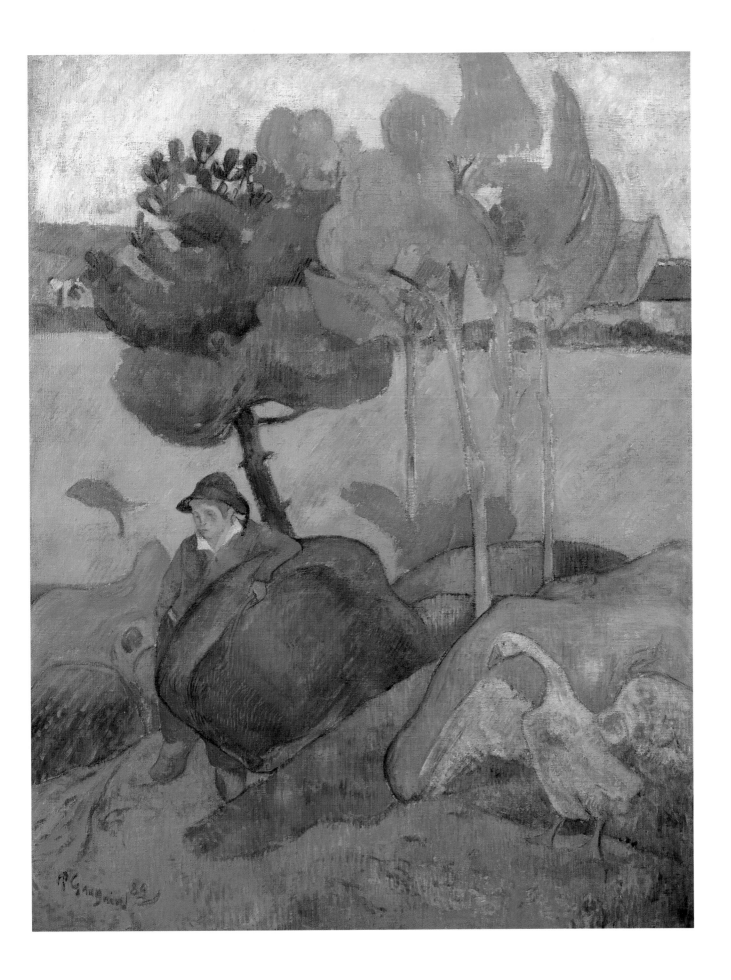

HENRI DE TOULOUSE-LAUTREC
French, 1864–1901
Model Resting, 1896
Tempera or casein with oil on cardboard
65.5 x 49.2 cm (25⅝ x 19⅜ in.)
At upper right, signed *HTLautrec* [HTL in monogram]
84.PC.39

Like Degas (see no. 44), whose work he admired enormously, Toulouse-Lautrec set himself the task of observing the daily life of Paris and attempted to capture the spirit and immediacy of everyday occurrences by working on site as well as in his studio. Lautrec and Degas were very well read and had extensive knowledge of paintings from previous centuries; both were exceptional draughtsmen and—like many of their contemporaries—had an almost Academic fascination with the human figure. Degas, however, was most comfortable in an elegant and detached world that allowed him to indulge a predilection for gracefulness, whereas Lautrec generally employed more diverse physical types and often rendered models in awkward or undignified moments. Lautrec's viewpoint was, nonetheless, generally sympathetic, and though he might occasionally mock what he saw, he clearly felt at home in the underworld of Parisian nightlife.

Degas and Lautrec both posed women nude or semi-nude—generally in very informal settings—to obtain compelling compositions. The present painting is one of several works executed by Toulouse-Lautrec in the 1890s that show a partly clad model viewed from behind. Degas also posed models in this way, although he usually represented them as bathing. Lautrec positioned his subject facing a row of small tables and chairs, implying a somewhat less private, and therefore possibly more suggestive, setting. By hiding her face and only partially showing the furniture, he permitted himself a relatively abstract composition and allowed the two-dimensional aspect of the design to assert itself. Lautrec deliberately eliminated any prominent receding lines that might carry the eye back into space, relying on differences in shape and color to achieve the same end, though less directly. The picture is rendered in tempera or casein, quick-drying opaque media that emphasize individual strokes rather than allowing careful modeling. A delight in revealing the means with which he rendered his subjects often led Lautrec to choose themes that contained obvious elements of artifice, such as the stage or aging women with exaggerated makeup. In the Museum's painting, however, this predilection takes second place to the artist's concern with form.

JEAN-ETIENNE LIOTARD
Swiss, 1702–1789
Portrait of Maria Frederike van Reede-Athlone at Seven Years of Age, 1755–1756
Pastel on vellum
53.3 x 43 cm (21 x 17 in.)
At top right, signed *peint par / J E Liotard / 1755 & 1756*
83.PC.273

It was during the eighteenth century that portraiture reached its most refined and cultivated state. The number of artists whose chief occupation was the painting of likenesses increased, and their subjects began to include members of the burgeoning middle class as well as royal and aristocratic patrons.

Born in Geneva, Liotard was trained in Paris, spent time in Rome, traveled with English friends to Constantinople, and then worked for varying lengths of time in Vienna, London, Holland, Paris, and Lyons, generally returning home to Switzerland in between his stays abroad. As his popularity spread, his sitters often came to him, but he remained one of the best-traveled figures of his time. Liotard was a very idiosyncratic artist whose personal habits and dress were unorthodox; he sometimes sported a long beard and wore Turkish costume. His highly individual life-style was reflected in his work and sets it apart from that of his contemporaries.

In his writings, Liotard insisted that painting should adhere strictly to what could be seen with the eyes and employ the least possible embellishment. Most of his portraits depict royal sitters or members of the aristocracy rendered sympathetically and without pomp or elaborate trappings. The backgrounds are simple or nonexistent, and the sitters often look away as if they were not posing.

The *Portrait of Maria Frederike van Reede-Athlone* was painted in pastels, Liotard's favored medium, between 1755 and 1756, when the artist was working in the Netherlands. Initially, he painted a portrait of the young girl's mother, the baroness van Reede, who then commissioned that of her daughter. Maria Frederike, just seven years old at the time, is shown dressed in a winter cape of blue velvet trimmed with ermine; she holds a black lap dog, which stares directly at the viewer. The girl's pretty features and fresh complexion make this one of the most endearing of the artist's portraits. One also sees here the range and spontaneity that Liotard was able to bring to the use of pastels.

THOMAS GAINSBOROUGH
English, 1727–1788
Portrait of James Christie, 1778
Oil on canvas
126 x 102 cm (49⅝ x 40⅛ in.)
70.PA.16

In the eighteenth century, as today, London was the center of the international art trade. The English at that time were, and remained for the next century, the most avid collectors of pictures from all of the major schools—Italy, France, Holland, Flanders, and Spain. Public museums did not yet exist, and except for a few private collections to which one might gain entry upon request, auction houses were one of the few places where a large number of artworks were regularly available for viewing. The auctioneer's role in the London art world was therefore considerable.

James Christie (1730–1803) was the founder of the London auction house that continues to bear his name. He began his career as an auctioneer in 1762 and within a very few years had made his firm into the most important and successful in Europe. An impressive figure, tall and dignified, Christie was on good terms with a wide range of society, including painters as well as aristocrats.

Christie's auction rooms were next door to the studio of his friend Thomas Gainsborough, who at that time was one of the most famous portrait and landscape painters in England. Gainsborough moved in the same circles that Christie did and was often commissioned to paint portraits of the collectors who frequented the auction salesrooms. The artist's affable personality was much appreciated, and it was said that his presence at Christie's sales contributed to the auctioneer's immense success.

Christie may have asked Gainsborough to paint his portrait in 1778, the year it was exhibited at the Royal Academy. Until the twentieth century, the portrait hung in the auctioneer's salesrooms. The subject is shown leaning on a landscape painting that is clearly in the style of Gainsborough; he holds a paper in his right hand, perhaps a list of items to be auctioned. The very fluid brushwork and the ease and grace of the pose which invariably flattered the subject are characteristic of Gainsborough's portraits.

FRANCISCO JOSE DE GOYA Y LUCIENTES
Spanish, 1746–1828
Portrait of the Marquesa de Santiago, 1804
Oil on canvas
209.5 x 126.5 cm (82½ x 49¾ in.)
At bottom right, inscribed *La Marquesa de Sn Tiago / Goya 1804*
83.PA.12

The inscription confirms that this painting was once a companion piece to a portrait of the sitter's husband, the marqués de San Adrian, which bears the same date and is now in the Museo de Navarra in Pamplona. An account of 1806 describes the portraits hanging together in the couple's palace in Madrid. They were painted during a period when Goya experienced relative calm and success and executed a large number of portraits. His sitters included members of the royal family, the aristocracy, and many friends among the intelligentsia, often liberals who, like Goya, favored the reforms promoted by the French revolutionary government of Napoleon. The marqués and his wife belonged to this last group.

The marquesa appears in traditional Spanish costume, specifically one worn when walking outdoors in the late afternoon or evening. She is seen out on a stroll at dusk with a very dim light illuminating the houses and trees on the slopes of the mountains near Madrid. The marquesa's pose is one often used by Goya for female portraits; she stands somewhat isolated from her surroundings, confronting the viewer with a hand placed on her hip in an assertive manner. From contemporary accounts we know that the marquesa was a woman with a reputation for licentiousness and had a series of lovers. Her early death at the age of forty-two—three years after the portrait was painted—was attributed to her profligacy. Clearly, she was a rather homely woman, and her reputation for wearing a great deal of makeup, including large amounts of rouge, is well attested in this portrait.

Goya's technique of utilizing bold strokes of relatively thick color alternating with thinner passages also emphasizes something of the brazenness of his subject's personality. He painted the gold braid on her sleeves with broad slashes of color, and the landscape behind her is rendered with huge daubs of paint wedged into the darkness of the hill. Typically, Goya has not attempted to flatter the marquesa; his ability to directly translate the sitter's character into paint is best seen with his more provocative clients. Goya's style set him apart from the majority of contemporary portraitists, who employed a more polished technique aimed at making even the most unattractive sitters appear beautiful.

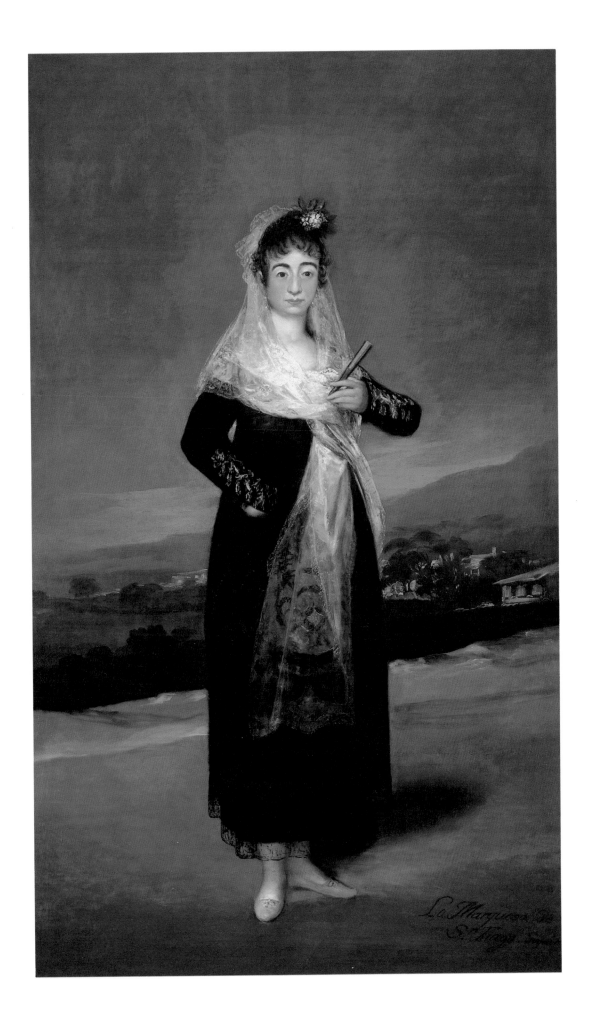

LAWRENCE ALMA-TADEMA
Dutch/English, 1836–1912
Spring, 1894
Oil on canvas
178.4 x 80 cm (70¼ x 31½ in.)
At bottom left, signed *L. ALMA TADEMA OP CCCXXVI*
72.PA.3

Sir Lawrence Alma-Tadema was one of the most popular and successful painters of his time. Although his reputation has suffered as a result of the change in taste that favored Courbet (see no. 38) and, later, the Impressionists (see nos. 40–44), his work still holds a fascination for us because of its extraordinarily meticulous technique.

The artist's style had its origins in seventeenth-century Dutch painting of everyday scenes, but the bulk of his work was dedicated to Greek or Roman subjects. Rather than the heroic or literary, however, the themes of his paintings are usually simple ones—to the modern eye even banal at times—chosen to represent daily existence in pre-Christian times. They also reflect Victorian sensibilities regarding social behavior. In the midst of the enormous economic upheaval and social discord the Industrial Revolution had brought to England, a segment of the upper class, to which Alma-Tadema belonged, continued to look back to the classical past as a simpler, idealized time. His was probably the last generation to do so with such unequivocal admiration.

The Museum's painting is one of Alma-Tadema's largest. He is known to have spent four years working on it, finishing in 1894, in time for the winter 1895 exhibition at the Royal Academy. Depicted is the Roman festival of Cerealia, which was dedicated to Ceres, the corn goddess. Although the edifice represented is essentially a product of the artist's imagination, he has incorporated portions of extant Roman buildings, and the inscriptions and reliefs can be traced to antique sources, reflecting the artist's profound interest in classical civilization and architectural detail. The painting still bears its original frame, inscribed with a poem by Alma-Tadema's friend Algernon Charles Swinburne; it reveals a particularly idyllic view of Rome: "In a land of clear colours and stories / In a region of shadowless hours / Where the earth has a garment of glories / And a murmur of musical flowers." *Spring* was an enormous popular success, and its fame spread to a wide audience via many commercial prints and reproductions.

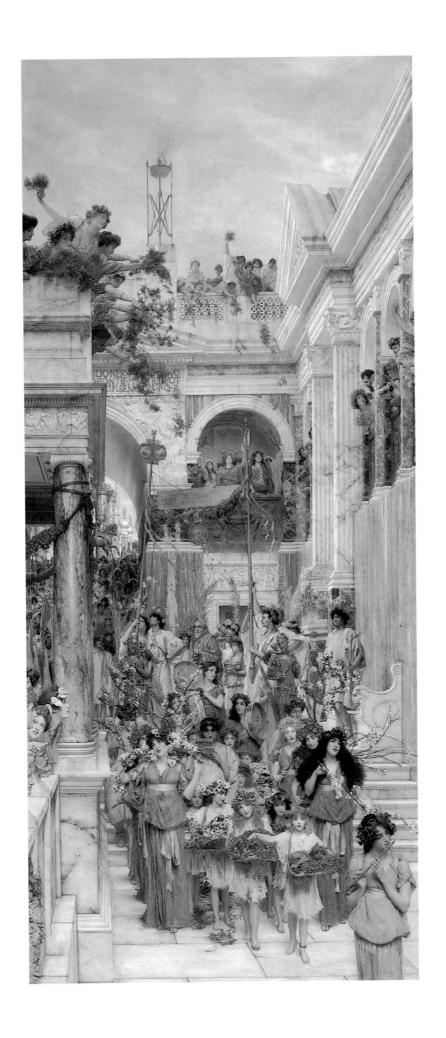

EDVARD MUNCH
Norwegian, 1863–1944
Starry Night, 1893
Oil on canvas
135 x 140 cm (53⅜ x 55⅛ in.)
At bottom left, signed *EMunch*
84.PA.681

Edvard Munch stands between the Romantic painters of the early nineteenth century and the early twentieth-century Expressionists. His work evokes the brooding quality and psychological isolation of the Romantic spirit combined with a stark, almost primitive directness of execution, which anticipates the comparatively uninhibited individualism of our own century.

Starry Night, a depiction of a coastal scene, is one of the few pure landscapes the artist painted in the 1890s. It was executed in 1893 at Åsgårdstrand, a small beach resort south of Oslo. Munch spent his summers there and often included one or more of the town's prominent landmarks in his pictures. In spite of the fact that this was a place of relaxation and pleasure, Munch's paintings of it often suggest personal anxieties and sometimes even terror.

Because the Museum's painting does not include figures or the town's pier—which would have been just off to the left—it has a more abstract quality than usual and an ambiguous sense of scale. It is an attempt to capture the emotions called forth by the night rather than to record its picturesque qualities. The mound at the right represents three trees. The vaguely defined shape on the fence in the foreground is thought to be a shadow, probably that of two lovers who are placed in the same setting in a lithograph of 1896. The white line before the clump of trees, which parallels the reflections of the stars on the sea, may be a flagpole, but it seems more like some natural phenomenon, such as a flash of light.

Munch's *Starry Night* was included in a series of exhibitions held between 1894 and 1902, each time with a different title. It was referred to as *Mysticism* or *Mysticism of a Starry Night* on occasion and was part of a group called Studies for a Mood-Series: "Love." Later it seems to have been included in the artist's 1902 Berlin exhibition as part of the same series, now called Frieze of Life. This group of paintings was a very personal, philosophical commentary on man and his fate and was imbued with religious overtones.

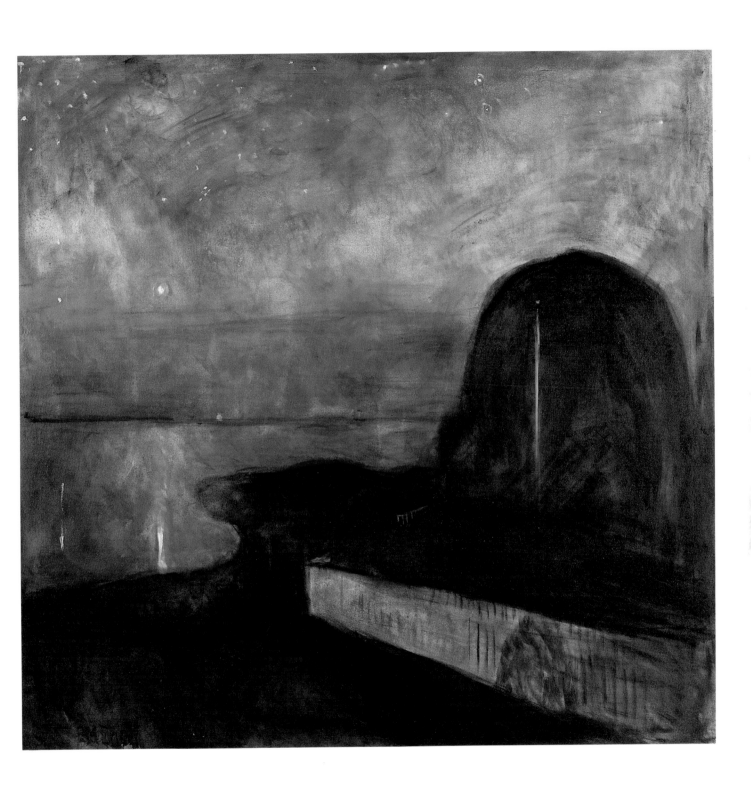

INDEX OF ARTISTS

The following list references entry numbers, not page numbers.

Christopher Hudson, Head of Publications
Andrea P.A. Belloli, Editor-in-Chief
Lynne Hockman, Manuscript Editor
Patrick Dooley, Designer
Thea Piegdon, Production Artist
Karen Schmidt, Production Manager
Elizabeth C. Burke, Photograph Coordinator
Charles Passela, Louis Meluso, and Thomas Moon, Photographers

Typography by Mondo Typo, Inc., Santa Monica
Printed by Dai Nippon Printing Co., LTD.